9X9/07 6/08

D0793278

9X9/07 6/08

NOV 3 0 2006

COLOR
and Creativity

BARRON'S

First edition for the United States, its territories and possessions, and
Canada published in 2006 by Barron's Educational Series, Inc.

Original title of the book in Spanish:
GUIAS PARA PRINCIPIANTES (PARRAMON GUIDE FOR BEGINNERS)
COLOR Y CREATIVIDAD (COLOR AND CREATIVITY)
Copyright © 2005 Parramon Ediciones, S. A.,– World Rights
Published by Parramon Ediciones, S. A., Barcelona, Spain

Authors: Parramon's Editorial Team
Text: Gabriel Martín Roig
Exercises: Gabriel Martín Roig and Óscar Sanchís
Photograhy: Nos & Soto

English translation by Michael Brunelle and Beatriz Cortabarría

All inquiries should be addressed to:
Barron's Educational Series, Inc.
250 Wireless Boulevard
Hauppauge, NY 11788
www.barronseduc.com

ISBN-13: 978-0-7641-5910-7

ISBN-10: 0-7641-5910-0

Library of Congress Control No.: 2005925271

Printed in Spain

9 8 7 6 5 4 3 2 1

CONTENTS

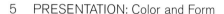

COLOR *and* FORM

When a person creates a painting, many different aspects contribute to his or her interpretation of the subject; color, however, is the artist's most effective tool for creating contrasts and the most ideal vehicle for moving the viewer. The use of color on the surface of the painting provides visual information and is a very powerful design element, a basic attribute of the painting, just like composition and form. Color is essential in helping us capture information from the infinite number of visual images and finding a way to interpret it.

Another important aspect of color is its emotive content, its ability to stimulate our senses. Color can be used to suggest and accentuate the character of a painting, causing an emotional response in the mind of the viewer. Color affects our emotions much more than we think, and it can cause any state, from delight to desperation, from torment to uneasiness, from serenity to excitement. It can be subtle, sensual, or spectacular.

When observing paintings, it becomes obvious that there are many ways to interpret and manipulate the chromatic effects. In this book we will show you some techniques for correctly using the interactions of colors to overcome specific visual challenges, for example, how to create natural descriptive colors, and how to use the expressive qualities of color to create interesting images with a personal style. We also cover practical and aesthetic considerations regarding the use of color in each medium, based on examples, step-by-step exercises, and a helpful notebook.

Becoming familiar with the potential of color requires firsthand experience like that provided by this book. The rest depends on you—on your willingness to practice and to see color as a protagonist, a most basic constructive element of painting.

PERCEPTION *and*

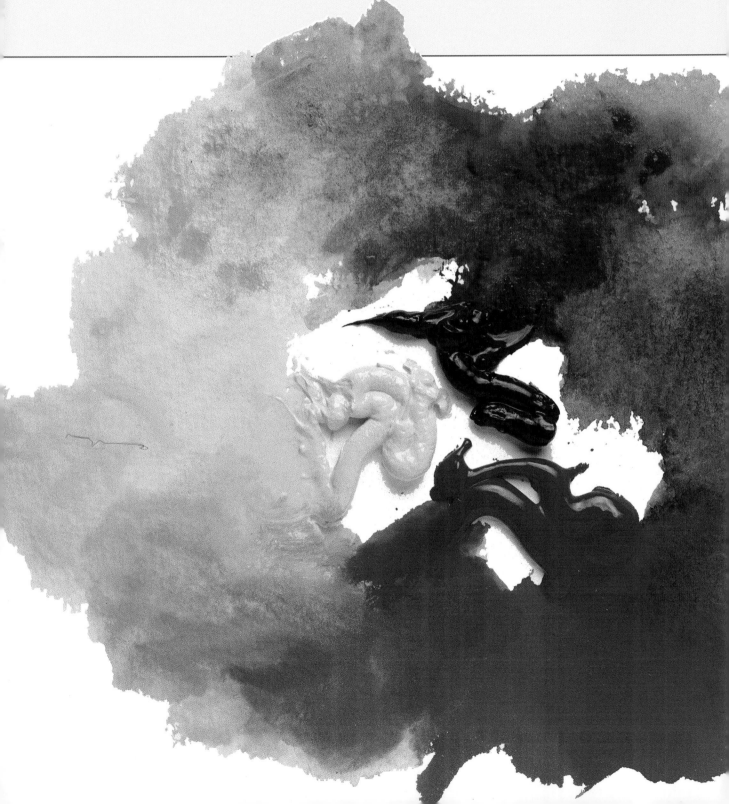

INTERPRETATION
PERCEPTION *and* INTERPRETATION

olor is one of the most personal and expressive elements of a painting. Using it skillfully will give any subject a distinctive character or feeling. Learning to appreciate colors and interact with them is the first step in creating a successful work of art. When working with colors, explore their characteristics and carefully observe how they modify each other, how they describe form, and how they infuse the painting with expression. At first it will be difficult to use color correctly, and you might even make a few mistakes; however, there are some guidelines, which we cover in this chapter, that will help you achieve the best results.

The Color
WHEEL

It may be surprising to learn that it is often difficult for us to recognize the colors of an actual subject. To learn to identify and classify them, it is necessary to understand how they are distributed—to see their locations on the color wheel, to understand how they relate to each other, and to learn how to make use of these relationships.

To understand how the color wheel is constructed, we can simply imagine a circle formed by three fans showing the three primary colors: yellow, magenta, and cyan blue.

A Diagram of the Primary Colors

The color wheel is a diagram of colors that can be organized in different ways, but the color relationships it describes are standardized. It is based on the idea that pure colors are derived from the three primaries: magenta, yellow, and cyan blue. They are defined as primaries because they cannot be created by combining other colors. This means that the basic primary colors are completely autonomous and have no chromatic similarity to any other color.

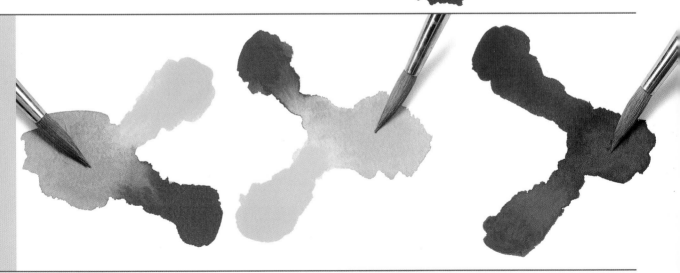

We mix two primaries together to make secondary colors. If we wish to make orange, we must mix equal portions of magenta and yellow.

We mix equal parts of yellow and cyan blue to make green.

Violet is made by mixing the last two primary colors, cyan blue and magenta.

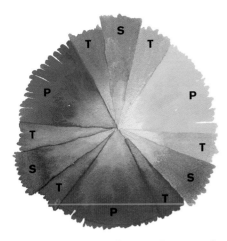

Between the three primary colors (P) we can place the secondary colors (S), which result from mixing the primaries in equal proportions, and the tertiary colors (T), which result from mixing the same colors in unequal proportions.

Tip

When two or more colors from the color circle are mixed, they lose strength; a color resulting from a mixture is rarely as intense as its component colors.

Inserting the Secondary and Tertiary Colors

We insert the color that is made from each pair of primary colors between them all around the color wheel. Thus, the wheel includes the primary and secondary colors. The tertiary colors can also be included by placing them between each pair of colors from which they are mixed. The colors that are located opposite each other on the color wheel are markedly different from each other and are called complementary colors.

Analyzing Colors

It is possible to analyze the colors of a subject by using a color wheel and small amounts of paint to help identify and harmonize the colors that we perceive. If the subject's colors are not well defined, like browns, grays, and neutrals, we must find the chromatic influences: a greenish brown, or a reddish brown, according to what blends best with the rest of the colors.

Theory and Practice

In actual painting, the primary colors like cyan blue and magenta are rarely used, so a similar paint must be chosen to represent the pure color. Different blues are usually used, like ultramarine and Prussian; vermilian or cadmium red are used in place of magenta. However, the substitutions do not invalidate the color theory. On the contrary, the painter becomes conscious of the mechanics of color implicit in his or her work.

In practice, ultramarine blue and cadmium red or similar colors are usually substituted for cyan blue and magenta.

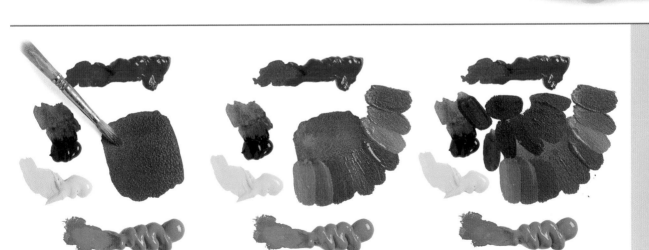

DEVELOPING A RANGE OF TERTIARY COLORS

The tertiary colors are mixtures of two primaries in unequal quantities, or of a tertiary and a secondary; for example, with magenta (primary) and green (secondary) we make brown.

Starting with the brown base we develop a range of lighter browns by mixing the initial color with different amounts of yellow.

We enlarge the range of browns by darkening the initial brown with different proportions of violet, to which we can add a dab of magenta to redden the final color.

9

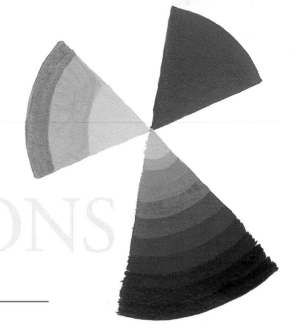

GRADATIONS
of COLOR

It is very important to understand the gradations of saturation, tone, and value of colors to model a form, locate the placement, and express the volume. Correct differentiation between the various gradations of the same color gives an immediate view of the layout and content of the painting.

The range of values of a color consists of lightening the color with white or darkening it with black. This will create scales like the cadmium red and the yellow seen here.

The Intensity of a Color
The amount of saturation or intensity of a color refers to its strength and brightness. A color is at its peak saturation when it is pure, without the addition of black or white, preserving the inherent strength of the original pigment.

The Difference Between Tone and Value
The terminology that is used when speaking about color consists of many imprecise and contradictory words. To avoid confusion, we will explain what we mean by each concept. Tone is an attribute of color that relates to the amount of movement of this color toward

that of its neighboring color. For example, a yellow can have a green or an orange tone. Value is the transition that a color makes from light to dark, that is, each grade of variation that a color will go through before becoming white or black. Therefore, when we mix a color with black or white we change its value but not its tone.

Mixing cadmium yellow with different blues will give us different results. Yellow mixed with cyan blue will give us a clean and bright green.

The same yellow mixed with dark cobalt blue; here, the resulting green still seems quite clean. Thus, cobalt blue and yellow do not make a very muddy mixture.

Finally, we mix the cadmium yellow with dark ultramarine blue. The result is very muddy. Instead of reviving the green, the ultramarine blue turns the color mixture brown.

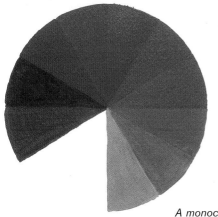

Here is a range of different red tones. Tone refers to the variations that a color can produce when mixed with its neighboring colors on the color wheel.

Tip

Colors of different tones that have the same value do not contrast with each other. They tend to optically blend with each other along their edges, causing the line that separates them to disappear.

A monochromatic work does not necessarily have to be black and white; grays and blues are often included in the mixture.

Monochromatic Scheme

A monochromatic scheme allows us to place full attention on the changes in value and the relationships between the forms on the picture planes. When painting a monochromatic subject, more than just a single color can be used; black and white are often added to create variations in color and saturation and thus avoid monotony. Some artists frequently break with the inherent unity of a monochromatic scheme by using neutral colors (grays and browns).

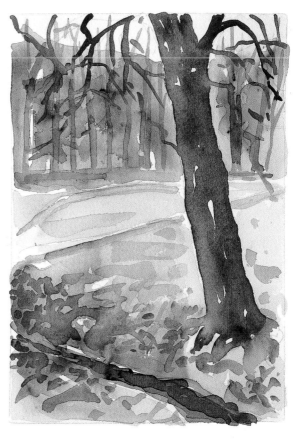

Analogous Values

One way of harmonizing a painting in a monochromatic manner is by beginning with an analogous color scheme that uses several values that are adjacent on the color wheel. Wide use of analogous colors can include three or four adjacent shades with many variations in value.

With water-soluble paint there are two basic ways to alter the values of a color. One way is to lighten the color by dissolving it with water.

The second way of creating a graduated value scale is by adding black or white to the green, according to whether we want to lighten or darken the color.

The last gradation is tonal, taking a color toward another adjacent one on the color wheel. In the center of the gradation, the green clearly shows bluish tones.

VALUES AND TONES

11

FORM
Through COLOR

The intensity and distribution of the colors in a painting usually determine the forms of the subject and give an immediate view of the composition. Defining the form based on color requires simplifying what we see and making use of the juxtaposition of colors to define the outlines of the objects.

Working with colors that have the same tone and that are near each other on the color wheel is not enough to differentiate the edges, since the contrast between them is not very strong and the outlines tend to run together.

Outlining Forms

If we want to emphasize a form, we should contrast two colors that are far apart on the color wheel and that are of different values, with different levels of luminosity. It is very effective to create forms by contrasting warm and cool, light and dark, complementary, and saturated and neutral colors. A strong contrast can be created between the object and the background, an effect that lasts even if we paint a blended, broken, or linear outline.

Decorated Surfaces

Allowing a patterned background to completely invade the painting will create a striking, abstract, and sometimes confusing effect. When placing decorative objects on the background, we should clarify the forms and the colors of the painting to keep the two planes from becoming confused. Furthermore, to keep a background pattern and an object from blending together, contrast should be created using a range of values and complementary colors.

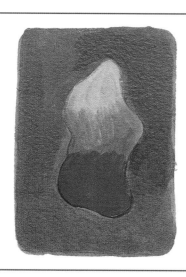

In this type of contrast, the near objects are painted in warm colors like yellow and red, while the background is a cool blue.

Using a single range of color, a form painted with very light colors stands out against a background covered with very dark colors.

Two complementary colors are used to achieve the maximum amount of contrast. In this case, a yellow form clearly stands out against a violet background.

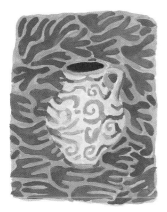

Two decorated surfaces (object and background), with similar designs and colors, tend to be confusing when put together.

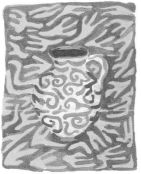

To make the object stand out clearly from the patterned background, the use of contrasting color ranges for the object and the background is essential.

Tip

The use of color is essential for identifying the subject when its colors are diffused and the outline is not sharp.

The Bezold Effect

It is possible to completely change the appearance of a work by substituting or changing a single color. This effect is usually achieved by replacing the color that occupies a larger area with a different one. Not only is the color modified, different forms stand out in one version and blend into the other with the single chromatic alteration. In some cases it is even possible to alter the entire work by changing a color, especially if it is a strong one.

Phantom Colors

Sometimes colors extend farther than their physical boundaries to tint larger neutral areas with their tones. In this illustration, the background is off-white, but the thin blue lines along the lines with dots influence the white background. The effect is more evident in the orange stripes. These phantom colors are easier to see when the lines have broken edges rather than being perfectly straight.

We can see here how the lines extend their influence to the off-white background. The stripes contaminate the background with their color. Where the jagged orange and green coincide, the background seems lighter and sparkling.

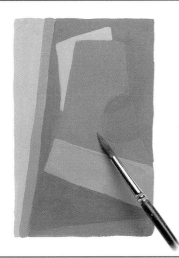

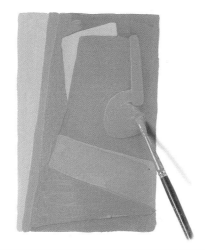

Here we paint an abstract design with orange, light raw sienna, blue, and pink. The painting mostly consists of warm reddish tones, and the contrasting blue areas are emphasized.

Changing a single color in this design alters the appearance of the other colors. We begin covering the reddish sienna areas with a medium green.

With the green color, the blue that previously contrasted seems to now be more integrated. Not only is the color modified, different forms stand out in one version and blend into the other.

Contrasting
Color RANGES

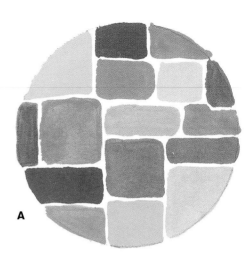

A

When we speak of color ranges, we are referring to families of harmonic colors, colors that never clash with each other. If we juxtapose several ranges with different chromatic tendencies we are then dealing with contrasting ranges. For example, warm colors, like red, orange, and yellow, placed next to a range of cool colors, like blues and greens, create the greatest possible contrast.

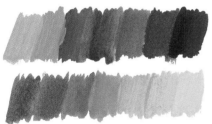

Colors in the same range are those that have colors in common.

Colors in the Same Range

Colors that are adjacent to each other on the color wheel form part of the same range. The most closely related are a primary and a secondary containing that primary color, through the intermediate tones created by mixing the two.

Warm and Cool Color Ranges

We associate the colors of fire—reds, yellows, and oranges—with warmth. Physiological research reveals that our bodies secrete more adrenaline under a red light. On the other hand, we associate blues and greens with the refreshing qualities of water and trees. Research shows that they slow down the heartbeat and relax the muscles. Thus the shades in the red and yellow area of the color wheel are called warm, while those in the blue and green ranges are called cool.

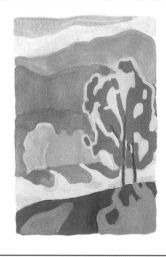

To understand how warm colors move toward the viewer, we first paint a sketch of a landscape with a range of cool colors.

When this layer of color has dried, we begin covering the ground and the tree in the foreground with warm colors that strongly contrast with the background colors.

Now the foreground seems to be closer to the observer than the planes with cool colors. It is commonly believed that warm colors advance and that cool colors recede.

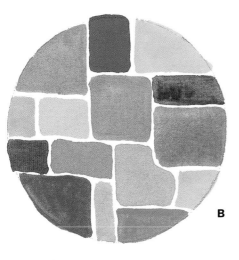

(**A**) The warm color range is mainly composed of reds, oranges, and yellows.

(**B**) The cool color range consists of greens, blues, and their derivatives.

B

Contrasting Ranges

In the physical sense, warm colors catch our attention more immediately than cool colors. They give the sensation that they advance toward the viewer from the surface of the painting, while the cool colors seem to recede. In the example below, all the color circles are exactly the same size; optically, however, the yellow seems to be larger than the purple, which itself seems larger than the blue. Saturated colors like the bright yellow tend to seem larger than less saturated ones.

Cooling Warm Colors

Warm colors can be cooled by adding white, black, or both at the same time (which is, of course, gray). The resulting colors continue to warm, but have a lower "temperature." Another possibility is mixing them with the cool tone that is nearest to their position on the color wheel; the result is a tone that is different from the original and cooler.

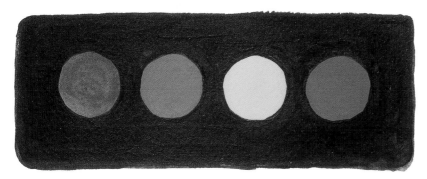

Although these four circles are of equal size, the two in the center, painted with warm colors (red and yellow), seem to expand more than the blue and violet ones.

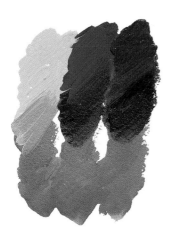

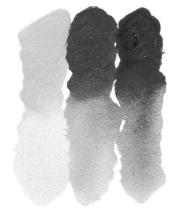

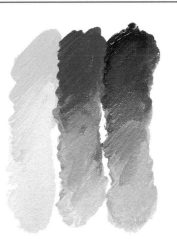

There are three basic ways to cool warm colors: the first way is to mix them with a color from the cool range, in this case cyan blue.

Another way is to dilute the color with water so it will become less saturated, and consequently lose its brightness.

Finally, you can reduce the color saturation by mixing it with white. White lightens and mitigates the brightness of many colors, cooling saturated warm colors.

COOLING WARM COLORS

Contrasting
COMPLEMENTARY COLORS

The colors that are located directly opposite from each other on the color wheel are called complementary colors. There are three main groups, each one consisting of a primary color and a secondary color: blue and orange, red and green, and yellow and violet. Each of these pairs of opposite colors produces a particularly vivid and striking contrast.

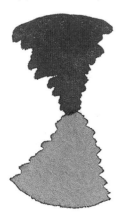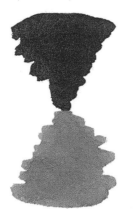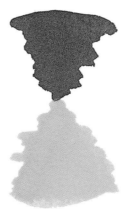

Contrasting Opposite Colors

The complementary relationships exist around the entire color wheel. The juxtaposition of the complements can produce a very lively, sometimes even disturbing, visual sensation. Opposite tones compete in attracting our attention, and colored areas next to each other will sometimes cause a physical effect, a sort of blinking or vibration. Some complementary colors are intensified when placed next to each other.

The complementary colors are opposite each other on the color wheel: red is the complement of green, blue of orange, and violet of yellow.

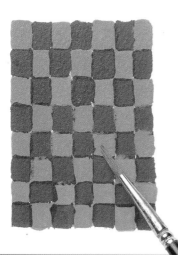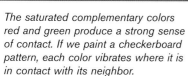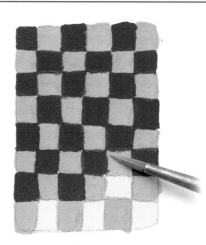

The saturated complementary colors red and green produce a strong sense of contact. If we paint a checkerboard pattern, each color vibrates where it is in contact with its neighbor.

The same happens with yellow and violet. Here, however, the vibration is less because of the great difference in value between the two colors.

To recapture the vibration between the two complementary colors, both should be of a similar value.

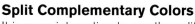

If we observe the edges where the two complementary colors meet, we will see that they intensify each other.
This optical effect causes the appearance of a thin imaginary line that separates them. This effect disappears when the colors are separated by wide white areas.

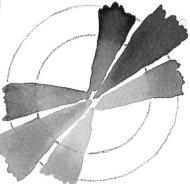

When painting with complementary colors, it is interesting to include split complementary schemes, which means using the colors adjacent to the complementary colors on the color wheel.

Induced Complementary Colors

To understand the induction of complementary colors you can simply look at a gray circle surrounded by an intense orange, which gives the gray circle a bluish tint; red will make the gray seem greenish, and yellow turns it slightly mauve.

Split Complementary Colors

It is more interesting to use the split complementary colors than the absolute ones, since they are more attractive. Using two adjacent tones on the color wheel along with their respective complements is known as a split complementary color scheme; for example, violet is the complement of yellow, while its split complements are blue violet and red violet.

Saturated colors influence the visual effect of a neutral gray by inducing its complement. Therefore, an orange square causes the gray circle to look blue, the green makes it red, and the violet gives it a yellow tendency.

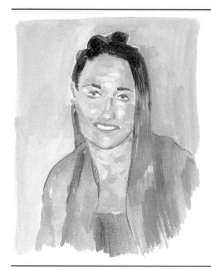 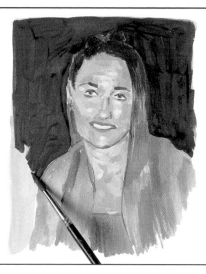 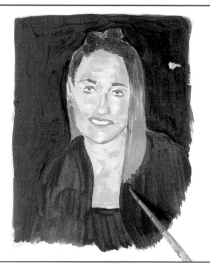

This model is painted with very light pink, ochre, and blue colors. We are not satisfied with the tone of the face and we want to lighten it so it will stand out more.

Instead of repainting the skin tones on the face with lighter colors, we will lighten them using simultaneous contrast. In other words, we will darken the adjacent colors.

We cover the background with violet and paint the clothing with Payne's gray. The contrast between the lights and darks creates a greater sense of light on the face.

MAKING A COLOR LIGHTER USING SIMULTANEOUS CONTRAST

If we place a single area of warm color on a background of cool colors, it will make the subject jump out and become the focal point.

COMPOSITION
Through Color

Color makes a considerable contribution to the composition of a painting. It creates visual structure through a more or less clear distribution of the contrasts of light and color. The contrasts of color ranges and color saturation help create the focal point of the painting, the spatial limits, and the relative abstract sensations of the space.

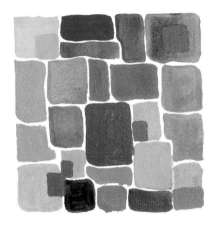

Emphasizing the Subject

The aim of many artists is to emphasize specific areas of a work to capture the attention of the viewer. One strategy consists of reducing the visual importance of everything around the subject so that it will stand out more through contrast; another is to paint the background using a cool range of colors while the main subject is done in bright warm colors. You must be careful that the intense color contrast is at the focal point of the painting; if equally intense and contrasting colors are used in several areas, it will result in a confused image.

If we overuse this effect and paint several motifs using areas of warm color over cool ones, the painting will seem unfocused and confusing to the viewer.

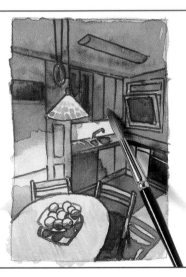

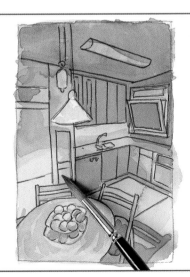

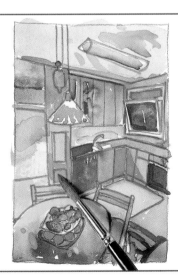

The intensity of the color, the contrasts, and the distribution of the tones modify the perception of the space. An interior with strongly contrasting light creates a dramatic and theatrical atmosphere.

A range of neutral colors (ochres, browns, and grays) harmonize well together, which implies the lack of harsh contrasts. The result is a calm and peaceful feeling.

Saturated color and strongly contrasting complements create a happy and lively interior. We lose the sensation of volume but we gain expressiveness.

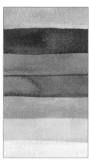

The color yellow seems closer, as do the rest of the warm colors, while the green and blue tones seem farther away.

Tip

Gradations create a clear effect of depth, implying the passage of dark values to lighter ones, or vice versa. Color gradations suggest the atmosphere of a landscape that fades into the distance, especially on foggy days.

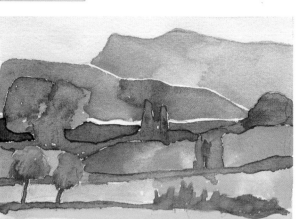

In this watercolor we apply the concept of advancing and receding colors using an analogous color scheme.

Far and Near Colors

Contrasts in color are greater in the areas that are closer to the viewer; they lose their saturation in the distance, and edges seem lighter, weaker, and tinted by the blue atmosphere. The effect of distance can also be indicated by painting the closer objects with warm colors and the farthest ones with cool colors. The warm colors cause the objects to advance toward the viewer, while the cool colors recede.

Creating Atmosphere

In addition to helping organize the space, color ranges and tone are essential for creating atmosphere. Spectacular contrasts of light and shadow with barely any middle tones create a theatrical atmosphere. A wide range of middle tones or a balanced tonal distribution usually creates a relaxed atmosphere; dark shades and saturated colors are more dynamic.

Creating Space

We can practice the optical effect of making small spaces seem larger using an interior. It is possible to make a ceiling seem lower if we paint it a color that optically advances. In painting landscapes we can create spatial planes using warm colors that advance visually and cool colors that create a sense of receding.

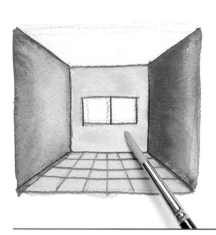
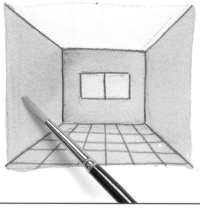
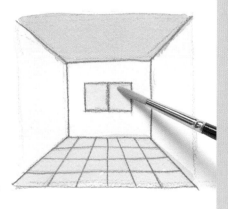

COLOR MODIFIES SPACE

Let's test this concept. We will make a sketch of an interior and then paint its walls with warm colors, while the floor will be covered with a neutral color wash.

This time we will paint the walls with cool colors. Comparing the two paintings, we will see that the cool colors make the room feel larger and the warm ones make it smaller.

To make the room seem higher we paint the ceiling with cool colors.

By superimposing several layers of clean and transparent colors, we achieve a brightly colored subject.

MIXING
Color on the Canvas

Learning to apply colors to the canvas or paper is the first step in creating a successful work of art. The artist must use his or her skills to create the illusion of a clear, bright light by applying warm and cool saturated colors to the canvas without previously mixing them on the palette.

Pointillism

The term "pointillism" is used to describe the technique of putting individual colors on the surface of the painting, in other words, juxtaposing small brushstrokes of saturated color. The colors that are applied are not mixed very much, since the optical mixing takes place in the retina of the viewer. In this way, an area with dabs of paint in strokes of blue and yellow is perceived as green. Even real green strokes can be complemented with dabs of blue and yellow.

Optical Mixing

Optical mixing is based on the principle that a mass of individual colors are mixed "in the eye of the viewer" to form desired tones and shades. Optical mixing achieves better results than working with the palette, because the pigments do not mask each other and the brightness of the individual tones is not lost, even when they are seen as a mixture.

Pointillism creates a surface covered with short brushstrokes of saturated color.

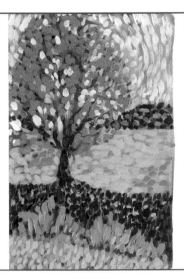

On a blue background, we cover different areas with small brushstrokes of green in the field and violet in the tree, the mountains, and areas of shadow.

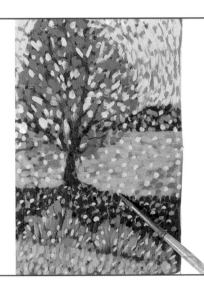

Over the previous base of colors, we lighten the sky with Naples yellow. This color is distributed around the entire painting with spaced brushstrokes.

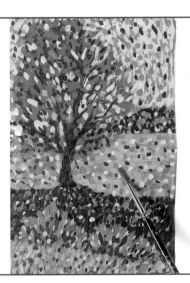

We finish it by applying red and orange brushstrokes. Although these colors do not appear in the real subject, they will add chromatic strength and help harmonize the subject if they are spaced well.

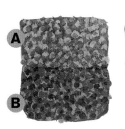

Tip

The smaller the dabs of color, the more evident the optical mixture. Keep in mind that this technique is based on color harmony.

Here we see three basic ways of working with pointillism. (**A**) The first consists of painting each area of color with short brushstrokes from the same color range. For example, a green area is covered with four different greens. (**B**) We can do the same with red. (**C**) The second method consists of blending the edges of the color areas so that both are mixed in a middle area. (**D**) The final step is based on the previous gradation, to which we add new strokes of blue. Including a saturated contrasting color in a uniform distribution helps to unify the painting.

Superimposing Layers

Very rich mixtures of color can be obtained using washes and diluted colors, with marvelous effects of depth and transparency. For this to be visually perfect, we must work with saturated colors. It can be a slow and laborious method, because of the amount of time it takes for each layer of color to dry.

Colors Interact

Colors and tones should never be considered in isolation, but in the context of their relationship with those that surround them. Each new dab of color that is added to a painting alters the relationship between the already existing colors: an intense red seems more intense between two light blue colors, and blue will seem darker if it is surrounded by light yellow brushstrokes.

When painting with short brushstrokes, keep in mind that bright colors increase their intensity next to neutral colors. Dark tones, on the other hand, seem more intense next to light ones.

It is possible to paint by overlaying diluted acrylic paint or watercolors. Here is a wash made with blue, green, and yellow.

After the color has dried, we overlay a new wash with various colors.

The colors are modified as they are superimposed. If we want the edges of the brushstrokes to be visible, we can allow each layer to dry before applying the next one.

OVERLAYING TRANSPARENT BRUSHSTROKES

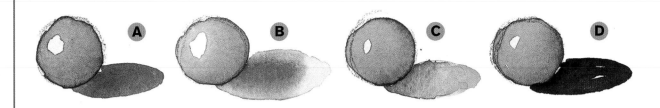

The Color of
SHADOWS

A shadow is an extension of the object in space, produced by light. It can be interpreted as a negative form; however, in works with strong colors it can capture the artist's attention to the point of becoming the protagonist and a determining element in the chromatic balance of the painting.

A. To create a strong shadow we apply a uniform wash to dry paper. This will give us clear edges.
B. If we carry out the previous step on damp paper, the shadow will be blurry.
C. The color of the shadow does not necessarily have to be uniform; two colors can even be mixed to make a gradation.
D. The darkest color is an intense black, which gives the work a particularly striking graphic impact.

Shadows with Color

The shadow that a body projects on the ground during a sunny day is a dark mass that indicates a lack of light, but this does not mean that when you paint it, the lack of luminosity should translate into a lack of color. Sometimes the effects of light and shadow cause the color to become apparent; the contrast can be more effective if blue or green colors appear in the shadow to stimulate a contrasting color range or complements to the sunny areas.

Corporeality of the Shadow

Tonal contrasts are usually stronger with projected shadows that have well-defined edges than with graduated shadows with soft edges. This gives the shadow a corporeality that it often does not have.

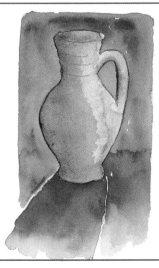

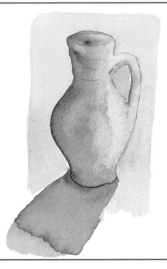

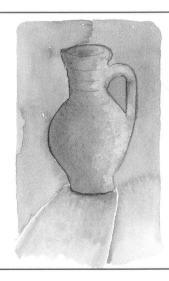

In colorist works we can paint the shadows with bright colors to create the greatest contrasts. Violet, blue, and their derivatives are an excellent option.

Green shadows are less common than blue ones, but they create a strong visual impact when the dominant color in the painting is yellow or red.

We can commit the error of painting the shadows orange or yellow. It is not a good idea to use warm colors for this, since they will seem like rays of light rather than shadows.

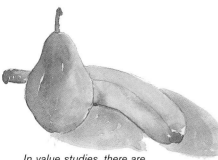

In value studies, there are barely any colors in the shadow. Neutral colors or gray work better.

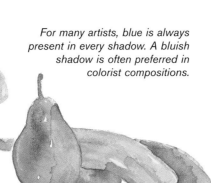

For many artists, blue is always present in every shadow. A bluish shadow is often preferred in colorist compositions.

Tip

Many artists begin their watercolors by placing the shadows with blue washes. This differentiates the illuminated areas from the shaded areas from the beginning.

Different Shading: Value Study

There are three different ways to paint a shadow. The most common is to paint it using a color from the same range, only in a darker tone. The Renaissance and Baroque artists used chiaroscuro contrasts to intensify the shaded areas; the value study approach of resolving the color of the shadows is therefore reminiscent of those works.

Blue Shadows

At the height of the Impressionist movement, shadows adopted a blue or violet color. This change of attitude toward color was based on the belief that if the maximum incidence of light is represented by the color yellow, the darkness should not be black, but the opposite color on the color wheel, violet.

Shadows with Complementary Colors

Another option is to always paint the shadow using the complementary colors of the lighted areas. For example, an intense blue in the shadow of an orange ceramic pitcher, or a green shadow complementing the red of an apple. The Fauvist painters frequently used this principle of complements to create works that were beautiful symphonies of light and color.

The shadow projected by the red objects can be painted with their complement, green.

A projected shadow does not necessarily have to be uniform. It can be constructed of small dabs of colors that little by little define the outline.

Violet, gray blues, and blue greens are added. Some of the colors run together to form gradations; others stand alone.

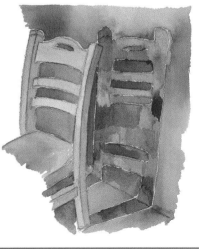

All that remains is to complete the outline of the shadow with the last additions of blue. For greater contrast, we cover the background with cadmium red.

TONES AND VALUES IN BLUE SHADOWS

23

CHROMATIC SCHEMES

When the chromatic effects of a subject are complex and varied, two different options are available. We can deal with them in a very thorough manner or approach the subject in a more selective way, revising the intensity of the shades and tones to organize the similarities and oppositions in a more deliberate manner. Here we analyze four basic methods for developing chromatic schemes that make the subject easier to comprehend.

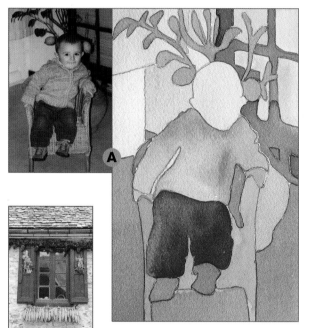

Chromatic Mass (A)
One of the fundamental chromatic schemes helps simplify and unify the different areas of color in the painting. After they are simplified, they are treated as flat washes.

Working in Blocks (B)
A landscape with a great variety of tones and values can be simplified with a drawing of geometric shapes, with blocks that enclose each different area of color. Then each color is painted inside its corresponding shape.

Inventing Colors (D)
Faced with a subject with few chromatic variations, it becomes necessary to invent colors where they do not exist. This model is dominated by grays, but the resulting chromatic scheme is rich in colors and contrasts that make the subject more attractive.

Grid Scheme (C)
This is a very complex method that permits a more thorough study of the subject. A grid is drawn on a photograph of the subject and on the sheet of paper. Then each square is painted in the dominant color of the corresponding square in the photograph. This will give us a fragmented image with valuable chromatic information about the model.

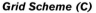

COLOR TRANSMITS *and* CREATES SPACE

The correct choice of one or another color in a subject is essential for transmitting a specific feeling to the viewer. Striking contrasts, as well as the use of warm and saturated colors, are the main ways of creating visual excitement. But it is not enough to arbitrarily place the colors on the surface of the painting—we should maintain an order, since the effect of depth in the work depends on this.

The starting point for our analysis is this mountain landscape with clearly differentiated grounds.

SHEET

PRACTICE

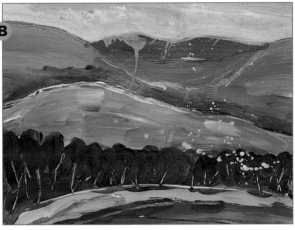

A. *Saturated red, yellow, orange, and magenta colors fill this composition. The selection of this range of colors affects the perception of the landscape, which seems to smolder under a burning sun.*

B. *Using an opposite approach, the same landscape is constructed with bands of cool colors. There is much less excitement here, and the light that illuminates the landscape seems more subdued. It transmits a greater feeling of tranquillity and a colder environment, typical of a winter scene.*

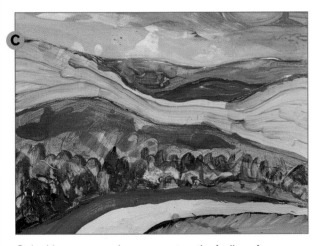

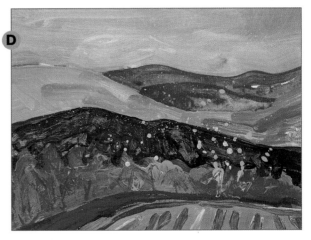

C. *In this new example, we recapture the feeling of excitement achieved through the extreme contrasts between the bands of warm and cool saturated colors. However, the space is quite ambiguous and incoherent. It is not able to communicate the effect of depth that is so evident in the two previous cases, since it seems that the distant mountains advance more than the foreground.*

D. *If we keep in mind that warm colors advance and cool ones recede, this should suggest the correct way to arrange the colors in a colorist landscape. The foreground is painted with saturated oranges and reds that move toward the viewer, and a sort of green color is in the middle ground. Cool colors are dominant in the far mountains, reinforcing the effect of depth.*

COLOR
Harmonies

HARMONIES

The close relationship between tones of the same family creates a natural harmony in which color unifies the forms and structures of the composition. This does not exclude the possibility of adding counterpoints of another color, as long as it does not create too much contrast.

The purest and strongest monochromatic studies are those that use only black and white.

Melodic Monochromatic Ranges

Using a single color as a base, the entire image is created through changes in value and tone. If the value is changed using only white and black or the complement, it is a monochromatic study. If the tone is also changed, it is called a simple melodic range or dominant tone range. In this case, we mix the base color with others to

shade it while maintaining the character of the dominant tone. Very suggestive monochromatic harmonies can be achieved with a few changes of tone and value.

The harmonic ranges of a single color are created by mixing it with other colors that are adjacent to it on the color wheel.

A common approach for harmonizing a painting is to work on a colored background. If we allow the background color to show through, it will unify all the colors of the painting.

Repeating the same color in different areas of the painting can also produce a unifying effect. The repetition of the green tones in the different grounds of the landscape harmonizes the painting.

If we want the colors of a subject to harmonize with each other, we can choose to cover the entire picture with a glaze or wash of color.

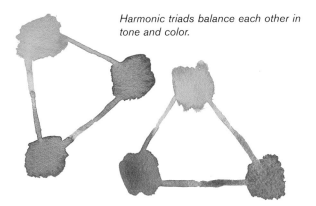

Harmonic triads balance each other in tone and color.

Tip

Neutral colors are essential for harmony in a painting. These are grays with tendencies toward some color. They are created by mixing complementary colors with each other.

This scheme exemplifies the use of a complementary accent. An orange accent breaks the monotony of the blues and adds greater interest to the picture.

The Dominant Role

Just like in landscapes, all subjects have a dominant color. They can also be organized in a way that color connections are created. It can be a challenge to our ability as colorists to evaluate the similarities of the colors instead of discovering their differences, which is the more common approach.

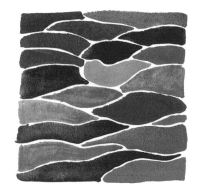

Using a Background Color

A background with a strong color behind the subject can create a very interesting effect, and sometimes it greatly increases the visual impact of the subject. If we allow this background to be visible, showing through in different areas of the picture, it will notably unify the colors.

Harmonious Triads

This is a method of creating harmony in a painting by combining three colors that are equidistant on the color wheel. The three colors form an equilateral triangle on the color wheel, and although none is the complement of another (which eliminates tension), the three colors compensate for this in their luminosity and boldness.

Harmony and Counterpoint

While a range of similar colors can create harmony, sometimes some contrast must be introduced to enrich the effect of the painting—an accent of color to attract the viewer's attention, or a counterpoint. The chromatic difference can be tonal, a light or bright color, or it can be a contrast between complements, or an opposition of warm and cool colors.

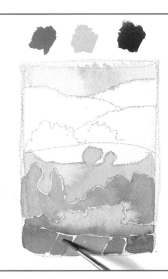

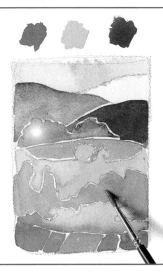

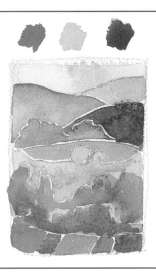

Here we paint a landscape with a triad of harmonic colors. The foreground is painted red. The middle ground is painted with a mixture of red and green, and green is painted behind that.

Now we add blue to the most distant planes: the outlines of the mountains. A touch of green and red are added to the washes to help tie them to the foreground.

We then paint the farthest mountains and darken the lower washes. The combination of three harmonious colors results in a work with no chromatic dissonance.

SKETCH WITH HARMONIC TRIADS

LANDSCAPE *with* HIGH KEY COLORS

In a landscape, the excessive presence of green can be a pitfall when it comes to incorporating chromatic variations that transmit light and energy. This problem can be resolved by mixing various tones of green with high key colors—pure tones like yellow, orange, and blue—and combining them with existing greens to make them work.

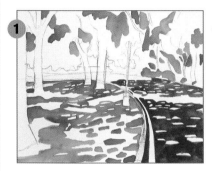

1. We begin by making a pencil sketch. Our first goal is to cover the areas where the vegetation seems more homogeneous with a green layer. Then we paint the asphalt road with ultramarine blue.

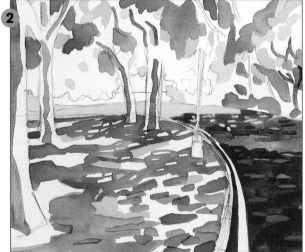

2. The most luminous areas of foliage are painted with cadmium yellow, the lightest parts of the ground with yellow, the medium areas in orange, and the light areas of asphalt in red and cyan blue.

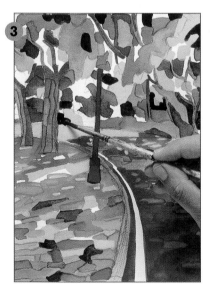

3. The brushstrokes become smaller but with brighter colors. We try to be creative with the greens that we use, mixing them with blues, purples, reds, and warm browns: ultramarine blue, Prussian blue, dark violet, carmine, red, and burnt sienna.

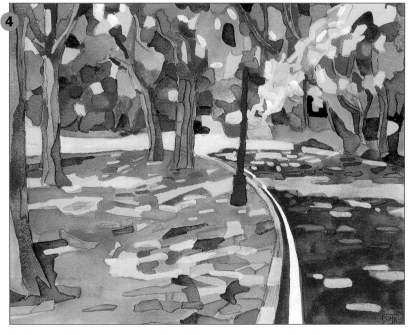

4. Reds and blues now suggest the foliage in the trees, while yellows, ochres, blues, and oranges indicate the leaves on the ground. To unify the brightest parts of the picture, we paint a layer of white gouache over the yellow in the background and the blue on the asphalt.

Still Life with CONTRASTING COMPLEMENTS

Red and green are probably the two complementary colors that contrast most strongly. Their medium tones create particularly attractive contrasts. In the following exercise, a still life, the combinations are painted with watercolor.

If we first make a small tonal scale by mixing the two colors in different proportions, we will see the richness of the intermediate tones.

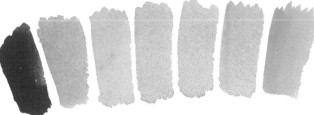

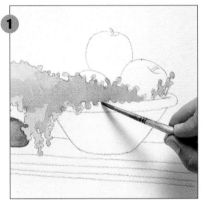

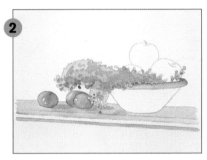

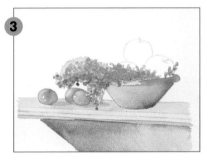

1. In the first phase, we paint the tangerines and the flowers using a limited range of tones: the mimosa with two tones of green and the three tangerines with red (to which we will apply a spot of green on the wet wash).

2. The shelf is painted with a medium gray, made by mixing equal parts of red and green. The shadows of the tangerines are painted over this with a reddish wash. The edges of the shelf and the bowl are then painted with a red wash.

3. We then mix red with a little green and paint the shadow that the shelf projects on the wall. The body of the bowl is then painted with a graduated, light red wash.

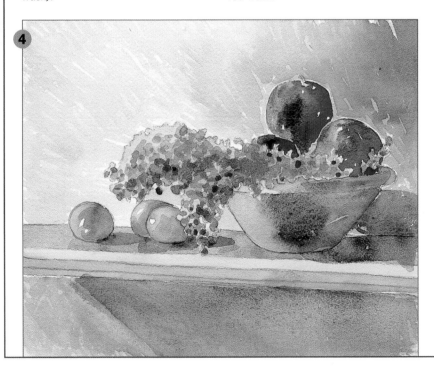

4. Now we paint the apples. We apply a dark wash to each side, one red and the other green, and blend them in the middle. New green washes are extended to the shadows of the bowl. To finish, we modify the tones and heighten some of the contrasts.

29

PRACTICAL

EXERCISES
PRACTICAL EXERCISES

I n this section, we develop the basic techniques for applying color and explain the approaches required for transforming the actual subject into a colorful, expressive, and creative work of art. If you pay attention to the exercises, it will be possible to learn and improve quickly by following the process and the very simple advice. Each exercise introduces a different subjective color treatment, and suggests specific techniques and solutions for each case. Through these studies, you will find your own personal style, or you will discover which style to use according to what you wish to express.

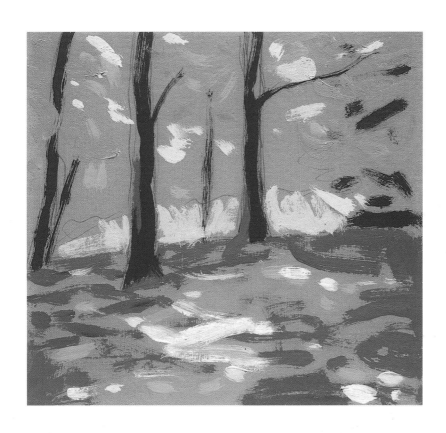

WARM *Color Ranges*

STILL LIFE *with* *Warm Color* RANGES

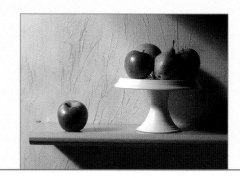

It can be quite practical to paint using a previously established color range. This is a good way to learn to control color.

This exercise with gouache interprets a simple still life with a harmonious range of warm colors; this means translating the actual colors of the subject into others within the color range. No cold colors are used in the mixture, so the red and orange tones clearly become dominant.

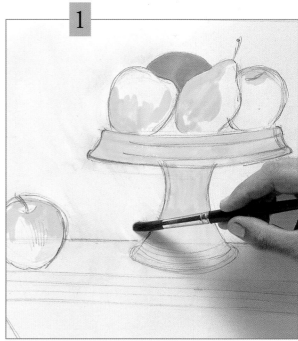

We sketch the model. The first strokes of color are yellow. A very transparent yellow is used to cover the background. The fruit and the fruit stand are painted with orange and a more saturated version of the same yellow.

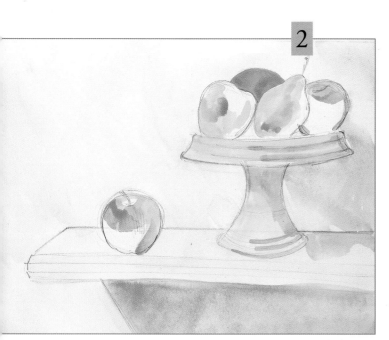

A little red is added to the yellow on the palette and mixed to make orange. We use it to add new transparent brushstrokes on the fruit, and we indicate the shadows projected by the wood shelf and the fruit stand.

Tip

It is common to use the warm colors to communicate the heat of a summer landscape.

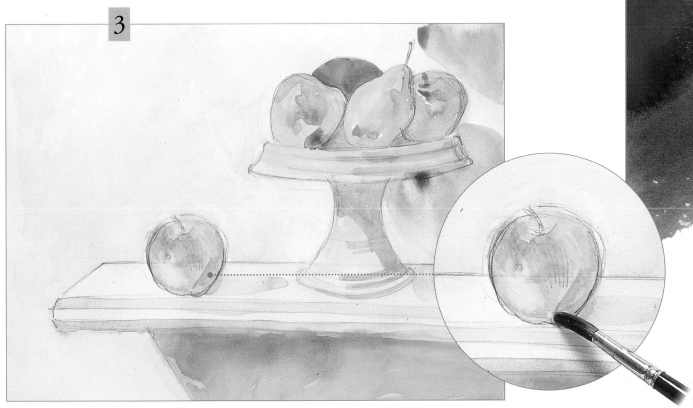

3

Now it is magenta's turn. We finish covering the white areas of the fruit with a brush charged with paint and a lot of water. The magenta is applied as a glaze over the orange shadows when they are still damp.

The color applications are light, made in a single pass without much pressure on the brush; otherwise we would smear the color that is underneath.

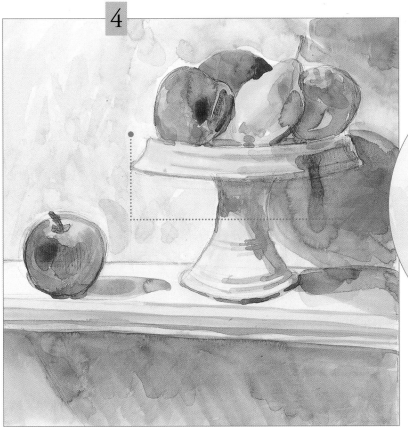

4

The background is painted with a very transparent red wash. As we paint, we leave some areas open, allowing the yellow underneath to show through; this will also leave more evidence of the brushstroke.

New brushstrokes of red are laid over the previous ones to intensify the color of the fruit. The darkest parts of the shadows are painted with sienna mixed with red; the contrast causes the illuminated areas to stand out.

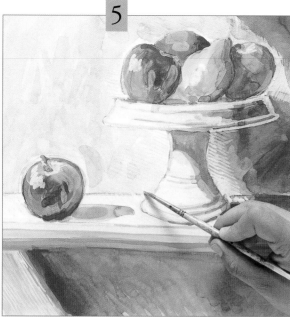

5

After the layers of color have dried, we paint the reflections of light on the fruit and the illuminated parts of the fruit stand with a fine round brush and white gouache.

Tip

Colored pencils are an ideal medium for finishing a work made using washes and brushstrokes. The range used in this exercise consists of only warm colors.

We use a sienna pencil to delineate the contour of the fruit stand, varying the degree of pressure to create the deepest value at the edge.

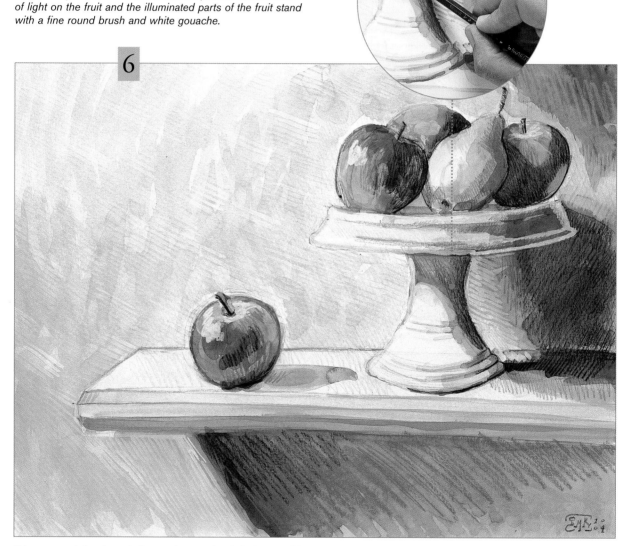

6

We must wait for the painting to dry completely before applying the final touches. Then, using colored pencils, we add red and orange hatching on the fruit. We mark the outline of the fruit stand and darken the shadows with sienna. Greater emphasis is added to the illuminated areas with some yellow and red lines.

A PEAR *with* WARM COLORS

You may have had difficulty understanding how a few brushstrokes of different colors can create the effect of volume in a painting of fruit. In this section, we present a brief study that shows the pictorial evolution of a piece of fruit treated individually. It demonstrates how each new layer of color is essential for creating tonal gradations in the form of the fruit and constructing its volume.

1. As we did before, we begin by drawing the piece of fruit. We use just a few lines to mark its approximate outline.

2. Using a yellow gouache, we cover the inside of the pear with a medium tonal wash. The irregular distribution of the color leaves small areas of white showing through.

3. After the yellow wash has dried, we overlay a second color. We cover almost half the pear with a homogeneous orange wash. The line that separates the two colors is not straight, but is wavering and curvy.

4. A new color is added over the orange wash. It is the same orange mixed with a little red, which darkens it. This time we have left a small dab of isolated color in the center.

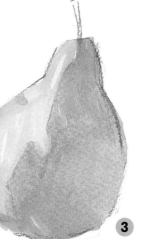

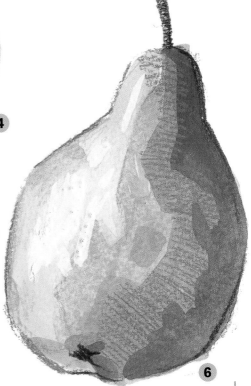

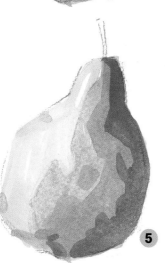

5. We define the dark shadow on the right side of the pear with red. As we can see, each new application of color is smaller in size, creating a clear tonal gradation on the surface of the fruit.

6. We then do the final retouching with colored pencils. They are used to recapture the outline, and we add some lines to the layers of orange color.

The Impact of COLOR

The Impact of COLOR

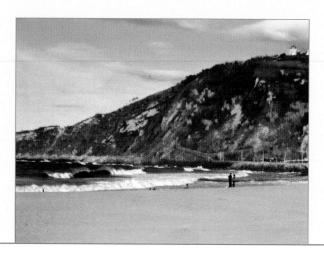

This exercise does not focus so much on the expressiveness of color in its maximum level of saturation as it does on studying how it impacts the canvas, with the expansiveness, gesture, and immediacy of large areas of color that contribute to heightening the chromatic effect. This treatment is often used when working in an area between figural work and abstraction. We will try to paint a coastal landscape using the collage technique with neutral colors (not very saturated and somewhat grayed). Oil paint is the best medium for working with the impasto and controlling the thickness and direction of the brushstrokes.

1

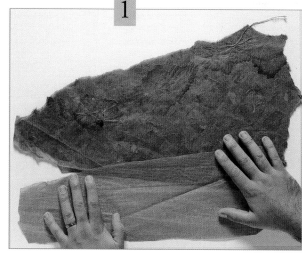

We approximate the model with two areas of uniform color indicating the hill and the beach. These are represented by two pieces of paper with different textures and colors, which are slightly overlapped on the canvas until a convincing composition is found.

2

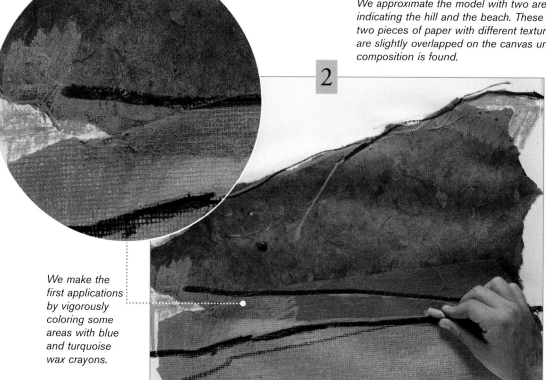

The next step is to attach the paper to the canvas with a clean brush and binder. After allowing the glue to dry for half an hour, we draw the outlines of the landscape, making wide bold lines with wax crayons of different colors.

We make the first applications by vigorously coloring some areas with blue and turquoise wax crayons.

Using a wide bristle brush, we paint the sky with wide strokes of blue diluted with turpentine. We paint the same blue, much lightened with white, over the previous blue. To counteract the purity of the white, it is a good idea to use a slightly dirty turpentine.

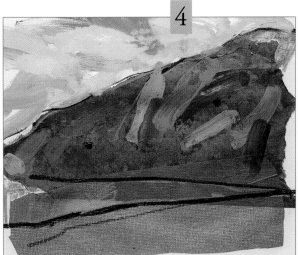

Working with the same flat wide brush, we add different values of green to the brown paper that will act as the hill in the background. It is a good idea not to completely cover the background so that both colors will interact to form a range of neutral colors (grayish and brownish greens).

4

To differentiate the background from the foreground, which is the beach, we will use another range of neutral colors with value contrasts, since the foreground has lighter colors. Beginning with ochre, we reduce its saturation by mixing it with white and again adding a large amount of dirty turpentine.

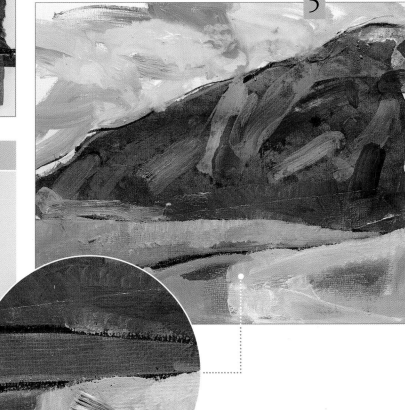

5

Tip

A good trick for making neutral colors is to work with very dirty turpentine. Adding a bit of turpentine to each color mixture will make it a little gray and muddy, creating a neutral color by reducing its brightness and purity.

We paint the foreground using a medium flat brush. The paint is mixed with a lot of turpentine and applied thickly, but without completely covering the reddish paper that is underneath.

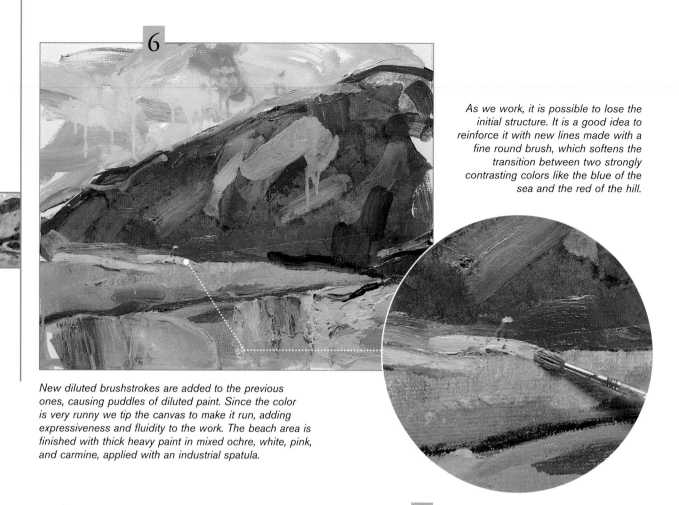

6

As we work, it is possible to lose the initial structure. It is a good idea to reinforce it with new lines made with a fine round brush, which softens the transition between two strongly contrasting colors like the blue of the sea and the red of the hill.

New diluted brushstrokes are added to the previous ones, causing puddles of diluted paint. Since the color is very runny we tip the canvas to make it run, adding expressiveness and fluidity to the work. The beach area is finished with thick heavy paint in mixed ochre, white, pink, and carmine, applied with an industrial spatula.

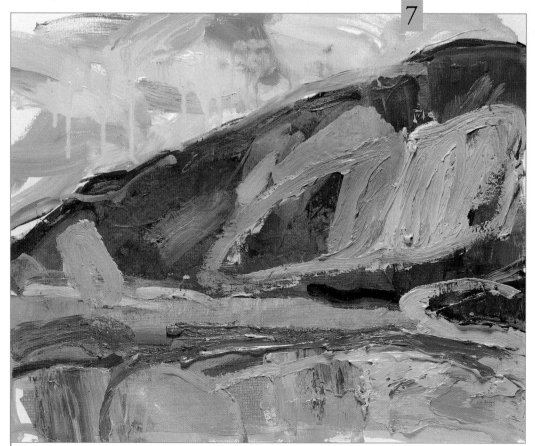

7

We could consider the exercise finished with the previous step, but to take the composition to a more abstract and expressive direction, we finish it by applying a heavy yellow impasto that covers the green background. The yellowish form is vague and has no relation to the real subject, but as a bright and luminous color it acts as the focal point of the painting. We do the same thing along the line of the beach with the brush charged with red.

An INFORMAL TREATMENT

In the previous exercise, the colors have been constructed in quite an informal manner, and many effects on the canvas are rough or seem to be uncontrolled. The abundance of dirty turpentine makes the colors grayish and runny, allowing them to harmonize with each other and the brush to flow easily across the surface of the canvas. Let's study some of the effects separately.

The sky was first painted with a blue layer that we immediately covered with a white diluted with greenish gray and a lot of turpentine. The white is applied in a very fluid manner to encourage it to puddle.

We applied greenish brushstrokes on the brown paper. If we do not mix the colors thoroughly on the palette, we get brushstrokes showing several colors in the same line.

If we brush across a dry area of the canvas, the line becomes streaked, that is, it shows marks of the bristles of the brush.

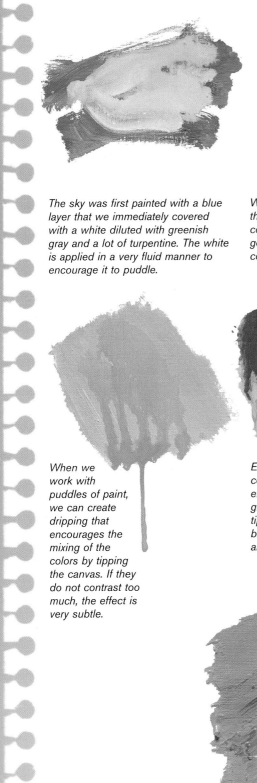

When we work with puddles of paint, we can create dripping that encourages the mixing of the colors by tipping the canvas. If they do not contrast too much, the effect is very subtle.

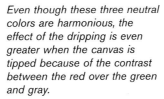

Even though these three neutral colors are harmonious, the effect of the dripping is even greater when the canvas is tipped because of the contrast between the red over the green and gray.

Lines are added right where two areas of color meet to reduce the contrast. This can be done by slightly inclining the brush and rotating the point while moving it along the surface of the painting. This way we take full advantage of the color.

The last additions of color are applied as impastos. Warm colors are mixed on the palette and then applied heavily on the canvas. This reduces the brightness of the red and the yellow and better integrates them into the painting.

39

Blocks of
COLOR

LANDSCAPE *with*
Blocks of COLOR

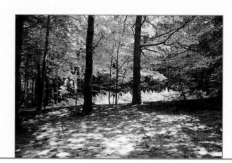

The following example is painted with blocks of color, that is, with small and individual strokes of color applied directly to the canvas. Working on the surface with dense and saturated colors tends to emphasize the contrasts; lines made up of individual brushstrokes become large areas of color with vibrant effects. We use oil paint because of its covering power and its creamy texture.

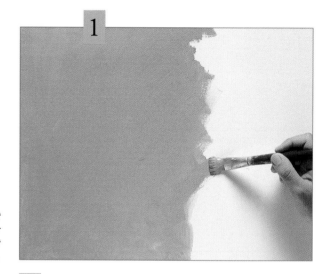

It is best to use dabs of color on a background that has previously been painted with a color. We cover the support with yellow ochre, using acrylic paint instead of oil because of its fast drying time.

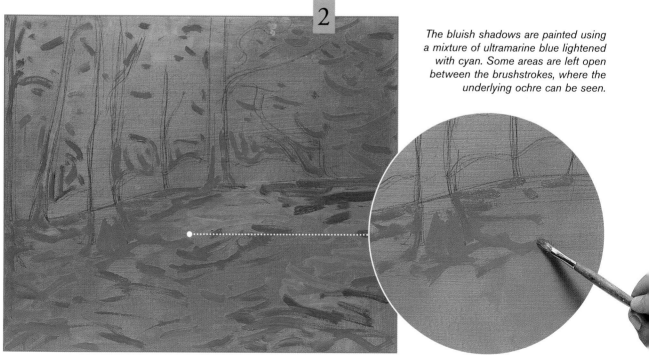

The bluish shadows are painted using a mixture of ultramarine blue lightened with cyan. Some areas are left open between the brushstrokes, where the underlying ochre can be seen.

After about twenty minutes, the first layer of color has dried and we can sketch the subject with an HB pencil. We paint the shadows first, in blue and covering a large part of the forest floor. We add a few strokes of color to the foliage of the trees.

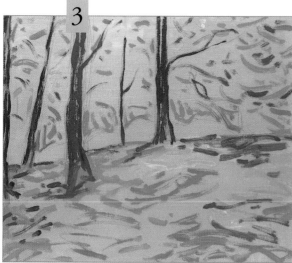

3

The first contrasts of light and shadow appear among the leaves on the ground. Flashes of yellow mixed with white stand out on a blanket of blue brushstrokes.

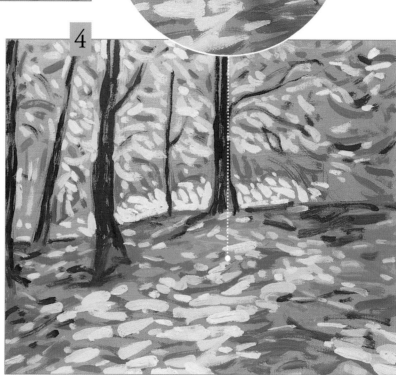

We now show the darkest parts of the painting. The trunks of the nearest trees are painted with violet. The brushstrokes do not form a mass of compact color, but leave open areas where the background color shows through, like the forest floor.

4

We paint the flashes of light on the ground in a mixture of yellow and white, and a yellowish pink. In the background we combine the light yellow with brushstrokes of a more saturated yellow in the foliage of the trees.

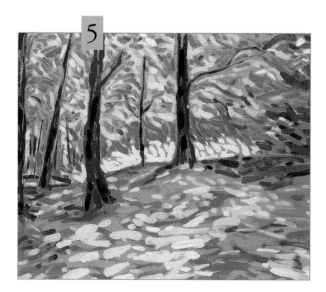

5

Over the yellow that represents the leaves illuminated by the light of the sun, we apply new dabs of a medium green, and a darker green in the more shaded areas. The green over the still-fresh yellow should be applied with a single stroke; otherwise we would lift the color underneath and both colors would become uncontrollably mixed.

Tip

Before attempting a colorful subject like this one, it is a good idea to be sure of our intentions concerning color so we can impart movement and dynamism to the painting.

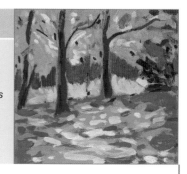

41

In a loose but controlled manner, we apply dabs of saturated cadmium red in the branches of the trees and a few more on the forest floor. Although this color does not appear in the real subject, its use adds vividness and warmth to the picture.

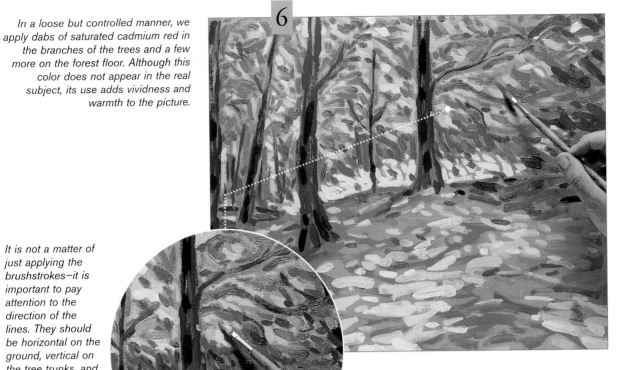

It is not a matter of just applying the brushstrokes—it is important to pay attention to the direction of the lines. They should be horizontal on the ground, vertical on the tree trunks, and expansive on the foliage.

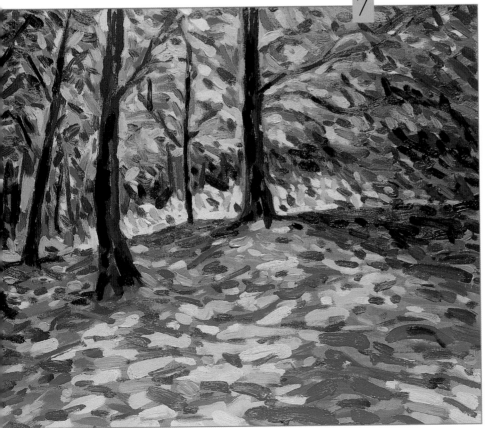

Tip

When applying short brushstrokes of color, it is enough to touch the brush a single time to the painting. It is an error to dab it several times, since the new color could become muddy from the underlying colors and we would lose the effect of saturation.

The final result is very vivid because the colors do not cover each other and the intensity of the individual tones is not lost. Not a single part of this painting is flat. All the tones and colors are constructed with an intricate web of short brushstrokes reminiscent of the Impressionist painters.

BROKEN COLOR *and* OPTICAL MIXTURES

As you know, the expression "broken color" refers to any area of color that is not completely uniform and covers a wide range of painting effects and techniques. These dabs of color are generally used with opaque media, and to a lesser extent with watercolor. Let's look at a sample of this.

Working with a charge of barely diluted color, we are able to create an area of color formed by rough brushstrokes that allow the texture of the fabric to show through.

This effect is the result of applying some color, allowing it to dry, and then applying another brushstroke of undiluted color over it. The granulated ochre color allows the red of the background to show through.

One of the most common effects of the broken color technique is the overlaying of short opaque brushstrokes that, through optical mixing, enliven the surface of the painting.

When the brushstrokes are applied dry, the edges of the colors are more defined. If we make two or three passes with the brush instead of one, the color will mix with the one under it.

When the lower layer of color is very damp and we apply a somewhat diluted application, we get striated brushstrokes.

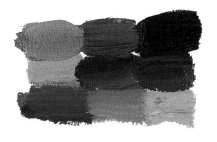

Broken color can also be applied by combining uniformly arranged brushstrokes that are juxtaposed without any mixing at all.

Pointillism is one of the best-known optical mixing effects.

In the "wet white" technique, the ground of the painting is prepared with a layer of thick white paint.

Then we cover the white with quick small brushstrokes of saturated color. The colors will mix with the white and take on light pastel tones.

Complementary COLORS

Still Life with Complementary COLORS

There are many ways to create a colorful and original painting. The combination of strong contrasts between complementary colors on the same canvas is a much used method. It is a matter of painting the objects and the most well-lit areas of drapery with pure and lively colors like orange, red, and yellow. Then the shadows that they project are resolved with applications of complementary colors, thus creating a very violent contrast. In the following case, the medium we use is acrylic paint.

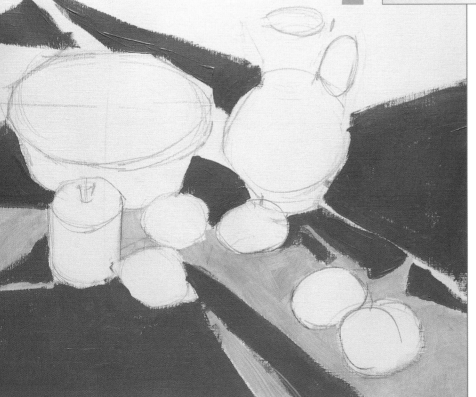

The initial drawing is very simple. We hardly spend any time on it, since it will soon be painted over. It is composed of a few circles that situate the pitcher and the fruit. The sugar bowl is drawn with a cylindrical form, and an oval is enough to represent the lid of the basket.

Using a thick, round bristle brush, we approximate the illuminated parts of the fabric with saturated yellow. We are aware that in the real subject the fabric is blue, but we are playing with the colors. Looking for a vivid contrast, we paint the shaded areas of the drapery with yellow's complementary color— a bright medium violet is the most appropriate.

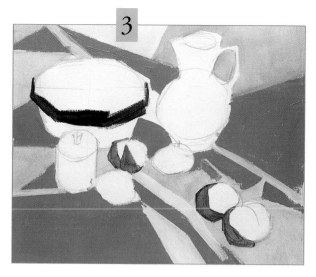

The background has been covered with strong contrasts created by the complementary colors violet and yellow. We apply areas of a lightened yellow in some spaces to soften the effect of the contrast, since the less saturated the color, the softer the contrast. The shadows on the apples are painted green, and the edge of the lid of the basket is painted a dark blue green.

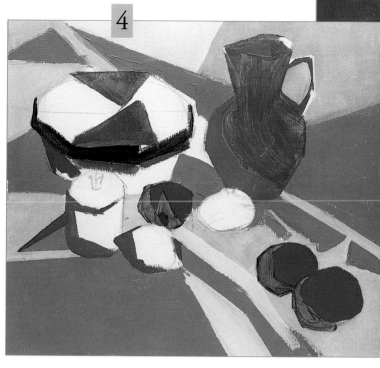

We paint the shadows of the rest of the objects, this time with a blue color on the left side of the pitcher, the sugar bowl, and the lemons. Based on the colors of the shadows, we paint the illuminated parts of the objects with the complementary color. Thus, the red of the apples is the opposite of the green shadow and the orange on the jar strongly contrasts with blue.

We add new applications of orange to the sugar bowl and the white parts of the lemons are painted with light cadmium yellow. The wicker basket is painted with an orange base color that is somewhat lightened with a touch of white. On top of this base we paint two geometric shapes with a brighter orange that help explain the form.

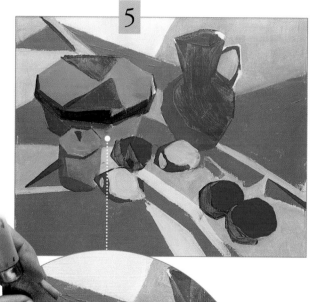

Tip

To avoid getting involved in details, reflections, textures, and various effects that can distract our attention from the purely chromatic experiment, we apply the colors flat and in the form of geometric shapes.

We use a spatula as a template for controlling the straight, striking edges of the flat planes of color.

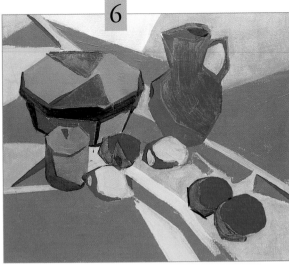

6

Tip

Glazing produces the opposite effect of contrasting complementary colors; instead of causing color discord, it tends to unify and even it out. A yellow glaze painted over an area turns the underlying colors toward yellow and causes the values to move closer together.

At this point, the exercise is finished. All the objects are composed of a single illuminated part painted in warm saturated colors and a shaded part resolved with the corresponding complementary colors. The result is a very luminous, optimistic, and exciting painting.

The best way to control the geometric shapes when using washes is to cut small card stock templates; they are laid over the surface of the painting to protect the edges of the forms.

After letting the painting dry, we will try another interesting chromatic effect: the modification of the underlying colors by glazing. If we wish to reduce the brightness of the color or the strength of a contrast, we can apply a more or less transparent wash over the area in question to tone down the color.

7

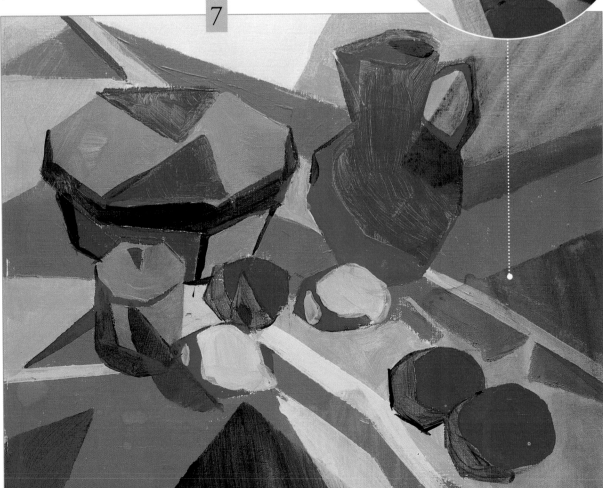

WAYS *of* APPLYING COLOR

There are many ways of applying color to the canvas. Each technique derives from a specific style and affects the final result of the painting; this means that, based on the method we choose, we can give it an impressionist, expressionist, or stylized treatment. Here we review the most common ways of causing the colors to interact on the canvas.

If we wish to model cylindrical or spherical objects, gradation is one of the most appropriate methods for working with colors.

Hatch lines, so popular with pencils, can also be made with watercolors and gouache.

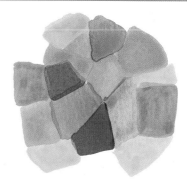

Working with blocks of color allows us to insert different saturated colors whose contrasts cause the surface of the painting to vibrate.

It is very common to work in blocks with watercolor, separated by a space that keeps the colors from optically mixing.

Impastos are created by working with dense and creamy colors mixed directly on the canvas. This may be the most expressive technique in painting.

Glazing is overlaying light layers of color that mix to form new colors. This technique produces very luminous paintings.

Washes allow colors to be mixed directly on the canvas; they can be used to create gradations and accidental mixtures of colors.

Here we overlay flat washes of color that intensify or tint the underlying colors. A graduated effect can be achieved with tonal scales like this.

It is very common to work with strokes of uniform color when using opaque paint like gouache, acrylic, and oil.

High Key COLORS

INTERIOR *with* *High Key* COLORS

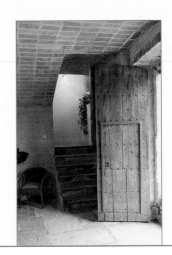

Saturated color converts an everyday subject into an image with a much more striking personal style. The following example clearly shows this principle. To get the most out of the colors, we are going to forget about the more subtle shades to work with colors that are saturated and barely mixed. This is an enjoyable kind of painting, and the technical process is within easy reach of a beginner.

We paint the canvas with an intense medium green acrylic that will dry quickly. Then we draw the interior with an oil pencil. The drawing is important, since the colors that we are going to apply will be flat and without modeling.

The background is painted with oils. Using cadmium red, cadmium yellow, and white, we apply four juxtaposed flat colors as a gradation on the door at the top of the stairs. Then we paint the arches in the ceiling with short brushstrokes of reddish colors.

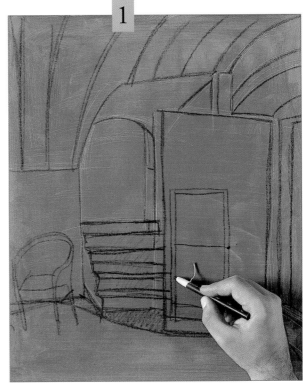

1

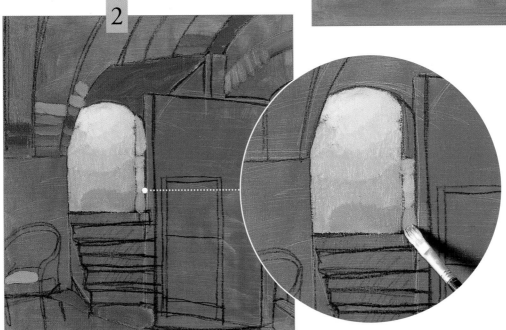

2

We recommend using a flat brush for working with thick and opaque paint.

Each illuminated area of the stairway must receive its share of flat orange color. We cover the ceiling with brushstrokes that offer variations of ochre, yellow, orange, red, and carmine. The green background stands out, acting as an outline around the individual bricks.

Now we color the door. It is covered with vertical impasto stripes of color, forming a light gradation. We begin with yellows, orange, and red at the left, and sienna, ochre, and olive green at the right. Some of these strips of colors are not completely flat, but contain a slight gradation.

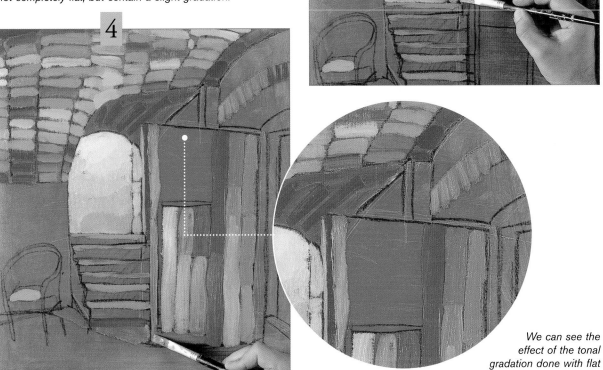

We can see the effect of the tonal gradation done with flat color brushstrokes on the door frame, with the values going from light to dark.

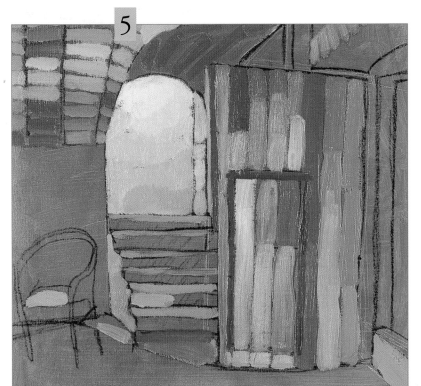

To finish the door, we cover the green background with wide new applications of reddish tones. Each brushstroke should differ from the colors next to it to correctly represent the row of wood planks that make the door. The molding of the smaller rectangular door is painted with a smaller brush and carmine brown.

Tip

Sometimes it is good to make a sketch of the subject beforehand to analyze the placement of the colors, which will be warm in the illuminated areas and cool on the floor and the walls.

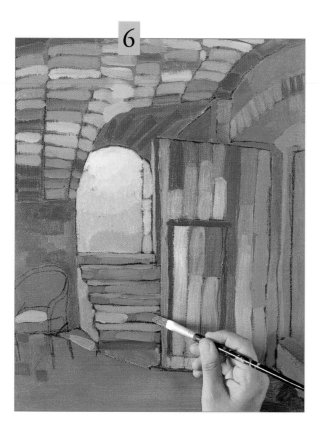

6

We paint the walls with blue colors. The bluish brushstrokes are unequal mixtures of cobalt blue, ultramarine, and cyan. The latter is very useful for lightening the blues without causing them to lose saturation. Incorporating blue creates a visual effect between the warm colors and the cool colors, a strong contrast of complements.

Tip

A range of bright and saturated colors can be created with little mixing, little use of white, and no black, browns, or grays.

Finally, we apply the whitened green that covers the surface of the floor and the arched doorway, and the intense green of the steps in the stairway. The lines that we leave on the floor help indicate the texture and the perspective of the room. We paint the opening to the exterior with a graduated yellow.

While the bright saturated colors flatten the description of the space, the green lines that show through from the background direct the viewer's gaze to the interior of the painting and cause the outline of each element to stand out.

The chair, the only piece of furniture, is resolved with a few dabs of the colors red, violet, and white.

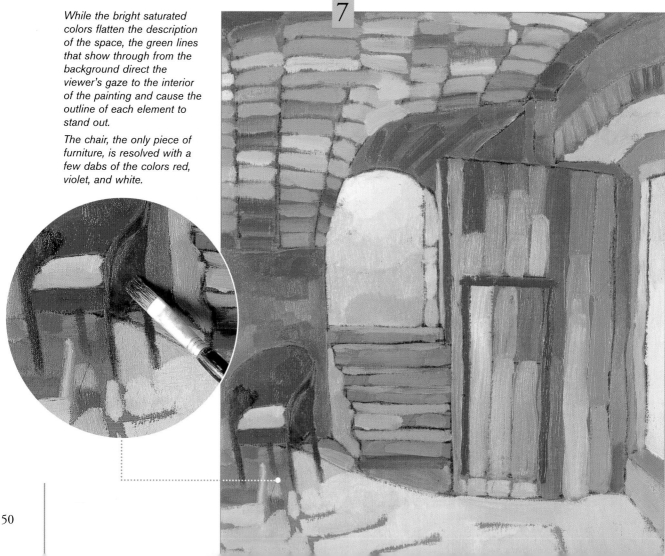

7

WAYS *to* SYNTHESIZE COLOR

The exercise we have just presented constantly strives to synthesize the planes; the forms are constructed through the use of color contrast instead of through modeling. Let's try to analyze, in an isolated and synthetic manner (without excessively manipulating the layer of paint), some techniques of applying oil paint to the canvas to better control the effect.

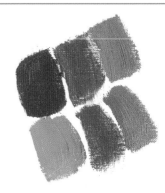

For the doorway above the well-lit stairs, we made a gradation by juxtaposing three areas of flat color to form a small tonal scale.

To better learn to create a tonal scale effect, we should practice with several colors. Here we have four values of green.

To paint the bricks in the arched ceiling, it is a good idea to develop various red colors. The two blocks of color in the middle are reds (cadmium and English). These colors can be used to create new ones if we add yellow to the initial red in different proportions and/or a touch of white.

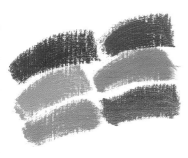

According to the consistency of the color, we can make a series of bricks with more or less defined edges. If the paint is thick and not very diluted, the brushstroke will have a rough, broken edge.

If, on the other hand, the color on the brush is more diluted, the stroke will have a clean, straight edge. However, the dilution can cause the color to be more transparent than in the previous case.

It is also good to control the gradation in uncommon situations. Here is a line painted with different blues that we have slightly graduated. They can simply be applied one next to the other, and then lightly brushed where they touch.

We painted the door using very dense and thick colors, one after another in a band. In the individual bands, there are no great variations of tone that would affect the feeling of continuity, but the adjacent bands do contrast with each other.

We work with areas of color rather than lines; here they are applied to allow the background color to show through. These intentional linear marks complement the colors of the painting.

51

MULTICOLOR *and* MONOCHROME

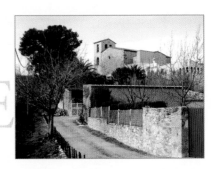

There are two clear ways of working with color. One is working with many colors and the interaction of saturated colors, where each color activates or is activated by adjacent colors that vividly contrast with them to create a vibrant and spectacular effect. The opposite case is the monochrome, which is created by making a painting from a single color with variations in its tones and values. The result is more homogeneous, calming, and harmonious. In the following exercise, we contrast these two ways of working, using the same subject. The medium we use is acrylic paint.

The initial sketch is extremely stylized. Using a graphite pencil, we first lay in the diagonals of the street and then we construct the main buildings as if they were blocks. When the drawing is finished, we go over it with a fine round brush and ultramarine blue paint.

The background is represented with gradations of cool colors, while the buildings and areas that we wish to emphasize are resolved with gradations of bright warm colors.

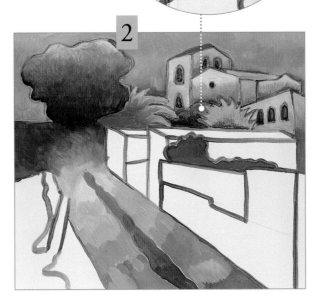

First we cover the largest areas of the painting with gradations: the sky, the vegetation, and the road. We work with cool colors, blues modified with violet or carmine and yellows modified with green. The buildings receive a warmer treatment since they are the main focal point.

Tip

To work with gradations, it is necessary to learn how to intensify and tone down a color. To do this, you merely place two saturated colors near each other and spread them with a brush until the space between them is covered with a gradation.

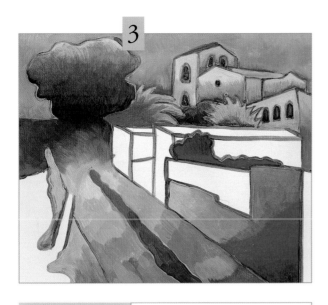

We are striving for a multicolored effect. First we consider which areas we are going to paint with the brightest and warmest colors. Then we keep in mind that the adjoining areas should be covered with gradations of cool color ranges so that the warm colors will stand out.

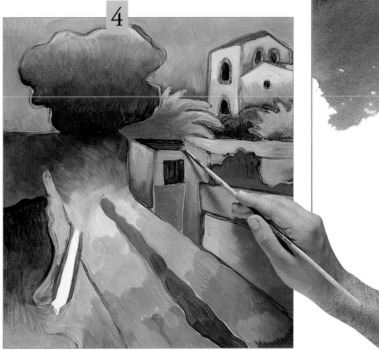

Tip

When placing several gradations of the same range together, it is important that the same colors do not coincide. For example, a light yellow should be next to a red because two adjacent yellows will barely contrast with each other.

We can see how the illuminated walls, painted with gradations that go from yellow to red, are located between shaded façades painted with greenish gradations. We work on each area of color by itself; this way, we preserve the initial blue line to achieve harmony and to maintain the importance of the line over the color throughout the exercise.

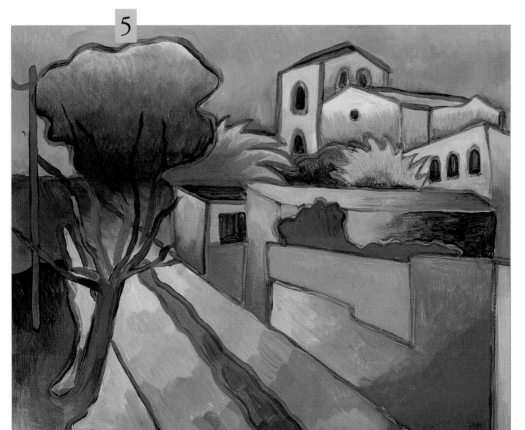

Working with gradations gives the painting a very volumetric effect. Despite the fact that the placement of the light is a bit disconcerting, this segmentation of color enhances the final multicolored effect, which is finished by painting the tree in the foreground and redrawing the blue lines that were lost during the applications of color gradations.

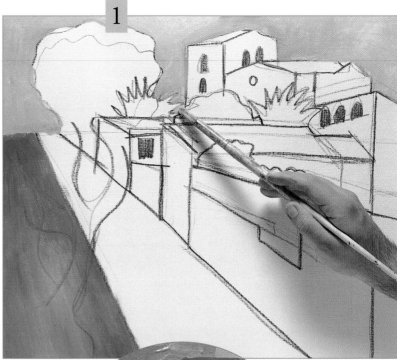

Now we will carry out an exercise with a clearly monochromatic tendency. We will paint the same subject, but with a range of violet tones that go from magenta to ultramarine blue. Beginning with a pencil sketch, we rapidly cover it with a whitish violet in the sky and another bluish violet to create a gradation along the side of the road.

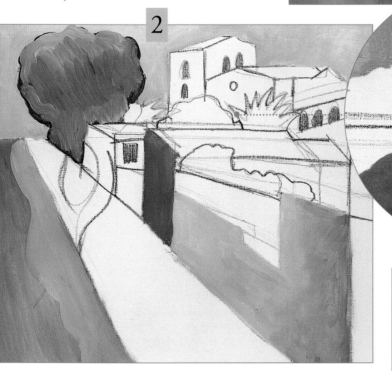

To create a gradation, we simply have to apply a layer of paint on the paper, in this case a magenta for the façade. While it is still damp, we add ultramarine blue to one side, blending it to create a gradation that goes to violet on the other side.

Using white, we lighten the new applications of blue on the façades along the road. The tree in the background is painted with darker paint; we mix it right on the canvas, taking advantage of the still wet paint.

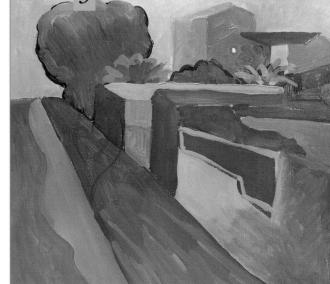

We cover the white areas of the paper with variations of the color violet. We must make sure that the adjoining colors have a different tone or value so that each area can be clearly distinguished, each plane standing out through the color contrast.

The entire surface is composed of violet areas that fit together like a puzzle. Using a fine round brush, we paint the lines that allow us to emphasize some edges that have become a bit blurred because of the similarity of the adjacent colors. We also paint the openings in the buildings with an intense violet.

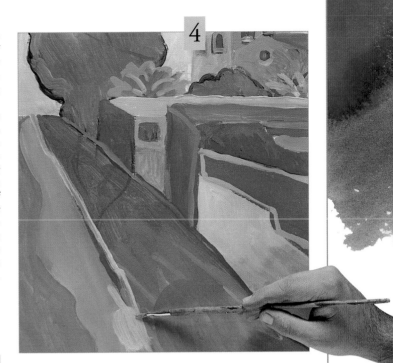

4

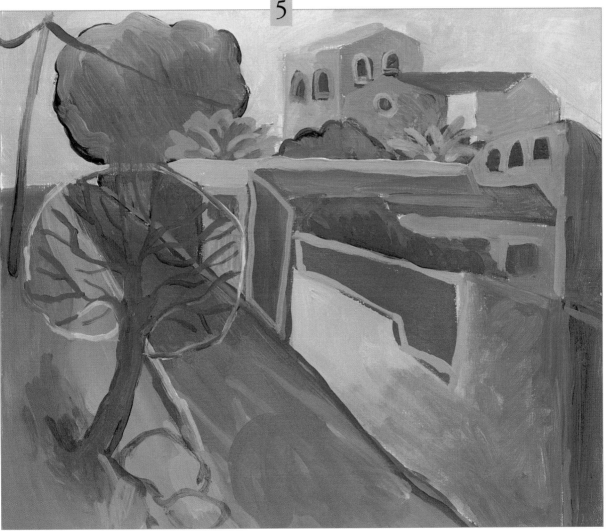

5

We conclude this exercise by extending a few more lines to modify the edges of some areas and by resolving the tree in the foreground. We do this by making a linear sketch with ultramarine blue. Then we fill in the trunk with violet and outline the branches with a whitish halo that gives it a more decorative feeling.

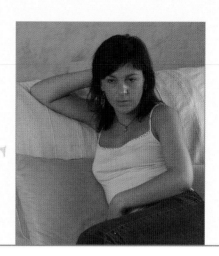

The PORTRAIT EXPERIENCE

In the following portrait, we use acrylic paint as the medium. We will avoid a too realistic treatment, focusing on correctly representing the forms and paying more attention to color. The main objective is the color treatment of the flesh tones of the model, which will take precedence over the previous drawing.

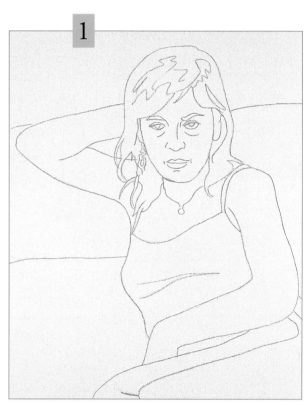

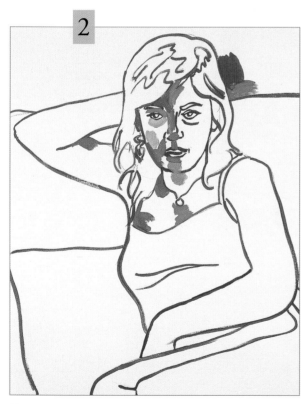

Using a fine round brush and red acrylic paint, we outline all the forms of the model with clear wide lines. These lines can be used as guides during the entire painting process. The first blue and violet tones are applied to the left side of the face.

Tip

The shaded areas of the flesh tones are indicated with variations of blue and violet, made by mixing ultramarine blue with a little carmine, white, cyan, and gray.

If we have experience, we can draw the portrait from a live model. If not, we can use a pencil to make a tracing from a photograph or project a slide on a white wall. An outline is sufficient for use as a preliminary drawing.

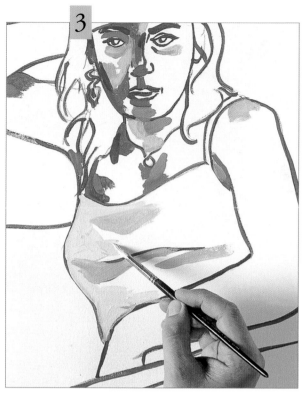

3

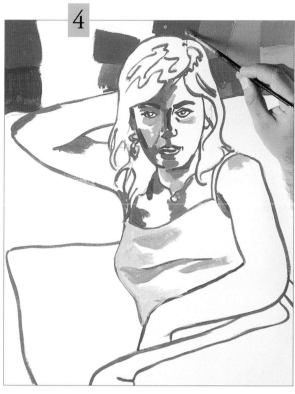

4

We paint the left side of the middle, the part we have decided to leave shaded, with cool colors. It is put together with blocks of color as if it were a puzzle.

For a moment, we stop coloring the model to resolve the upper part of the background. The uniform magenta color of the real wall is translated into a series of blocks of warm colors. We place yellows and oranges to the right and blocks of carmine tones to the left, simulating the natural flow of light.

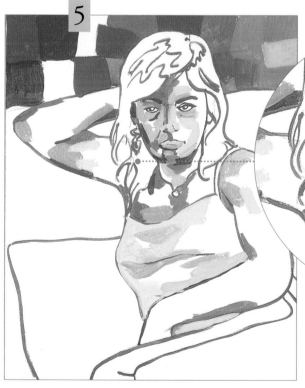

5

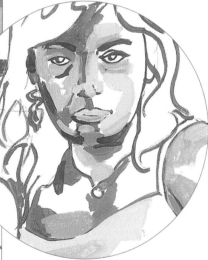

In an enlargement of the face we can see how the original red lines are not completely painted over. Some of them are quite visible and complement the different colors.

We approach the shaded area by juxtaposing bluish brushstrokes; the illuminated side, on the other hand, has pinks that are more reminiscent of the natural flesh tones. We try to model the face using these new applications of color.

Tip

The background at the top of the painting is covered with squares of juxtaposed warm colors that break up the uniformity of the wall by adding a more attractive play of colors.

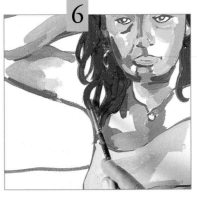

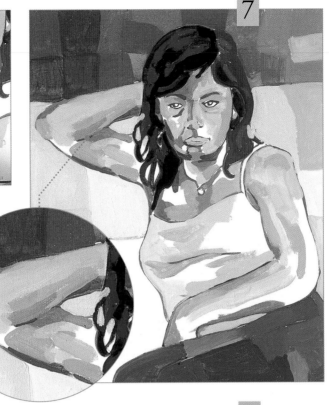

We use a sienna color practically straight from the tube for the hair. When the sienna is dry, we apply orange paint to the right side of the hair and blue to the left to differentiate between the shaded and illuminated parts.

The sofa is painted with several squares of whitened colors. A well-designed background should keep the focus on the model, and the forms, the tones, and the colors in it should be balanced and should complement the overall design. The pastel colored squares add vertical and horizontal lines that reinforce the composition of the painting.

There are no rules that determine where each color should go—the treatment is somewhat anarchic. Let yourself, then, be guided by intuition and take care that one color does not clash with the one next to it.

We finish modeling the figure with new applications of warm colors: pinks and light oranges for the skin tones and pinkish white on the shirt. The repetition of colors in several areas of the skin helps to preserve the unity of the painting.

Tip

We also paint the sofa with geometric patches of color. The outline of the figure is reinforced by reducing the intensity of the colors, which are mixed with white, giving them a more pastel tone.

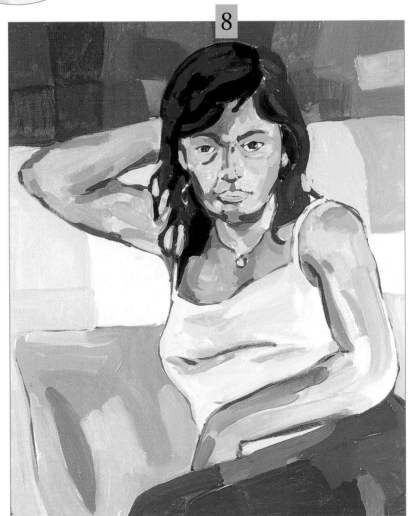

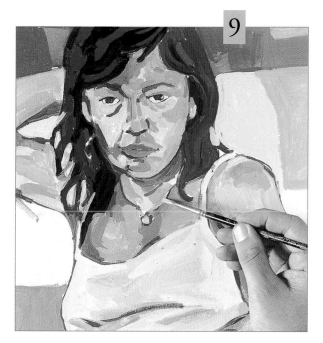

9

Using a fine round brush, we add orange and yellowish touches to the outline and the arm of the right side of the figure. We also add blue and violet to the outline and arm on the left. The contrast between warm and cool colors adds to the sense of volume and creates more contrast between the areas of light and shadow.

The final applications of color should be very saturated, opaque, and small. They should contrast and clearly be different from those applied in the earlier phases.

We make the final applications of blue, orange, and yellow with more opaque paint to create an expressive effect. With the contrast between the warm and cool colors on both the face and the body, and some very loose brushstrokes laid over the skin tones, we have created an unconventional portrait that is full of life.

10

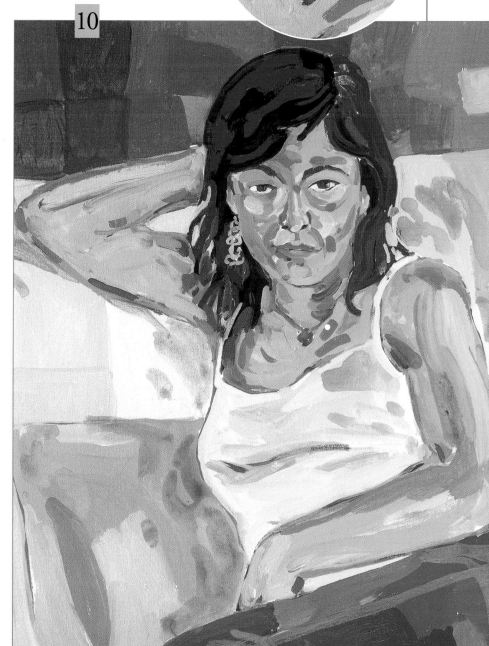

Tip

The background of the painting should be designed as if it were an abstract composition upon which the figure will be placed. Here is a sketch of the background colors.

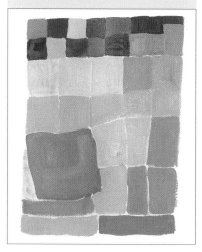

STUDENT
Work

Now let's see how the previous exercise, done by a professional artist, was done by art students still in their formative process. The students, just like the artist, have painted portraits choosing different models and compositions in which the color treatment becomes the main protagonist. Different ways of working and interpreting the subject offer diverse results, all equally interesting and noteworthy. Learning from their successes can help inspire you and help you make progress in your work.

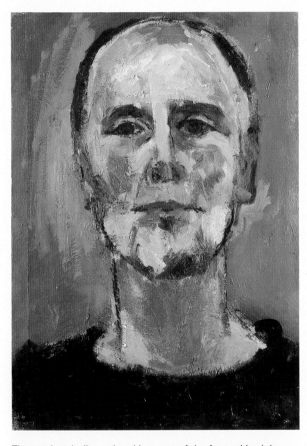

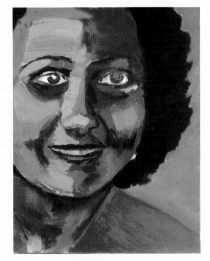

The skin color was built up by overlaying blue colors, first working with very diluted colors and mixing ultramarine blue and cobalt blue with ochre, sienna, and black. Next we can see the thicker light blue color in the lightest parts of the face. The modeling is succinct and results in a very stylized treatment. Painted by Dulce María Rodríguez Martínez-Sierra.

The student built up the skin tones of the face with pinks, ochre, sienna, yellow, and other brown tones derived from an orange color range. The background is painted with green, the complementary color of orange, to add more relevance to this color range and emphasize the outline of the figure. This contrast accentuates the strength of the colors in the face. Painted by Gabriel Sabanés.

In this composition, the figure emerges from the overlaying of blended colors that barely define the hair and facial features. The absence of a preliminary drawing gives the work a very painterly look that is created with just four colors: magenta, violet, pink, and a sky blue mixed with a lot of white. There is an intense distortion of the figure with blurry outlines, which is only identifiable through the moderate contrasts of the colors. Painted by Caterina Solivellas.

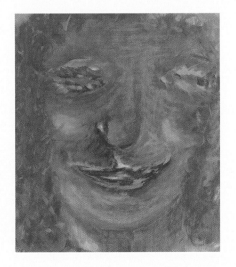

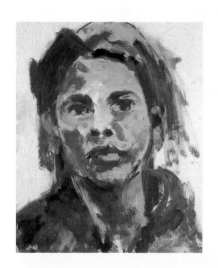

Here is a monochromatic treatment with sienna, white, black, and a little ultramarine blue. The color of the skin tones is created with values of sienna mixed with white, and we can see the same brown color mixed in different proportions with black in the hair, facial features, and the large shadow on the neck. In the dark mixture in some parts of the hair and in the clothing, we can make out the presence of ultramarine blue, which slightly accentuates the monochromatic browns. Painted by Gabriel Sabanés.

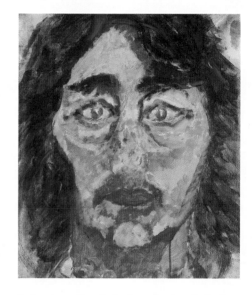

A drawing with a lack of academic criteria, the use of bright colors, and a brushstroke full of colors that are mixed directly on the canvas define the approach of this painting. The skin tones seem lively, built up with a range of roughly mixed warm colors. Touches of ultramarine blue revive the contrast of color ranges in the dark parts of the hair. The only lines are in the eyes, which become the focal point of the work. Painted by Rosa Puigcercós.

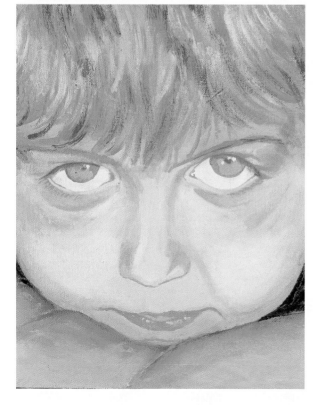

This other monochromatic treatment, done with an orange brown, barely shows changes in tone. The different chromatic variations were made by tinting the color with white and darkening it lightly with a little burnt umber. The paint has been quite diluted with water, which allows the modeling to be done with light gradations whose brushstrokes are barely visible. Painted by Maria Luisa Vilá.

Painting of FLOWERS

A Painting of Flowers with EXPRESSIVE BRUSHSTROKES

Flowers allow a very free use of color. A few simple saturated and nervous brushstrokes become colorful fresh flowers. These works let us make use of transparent overlaid colors, the dominance of the gesture, and the direction of the brushstrokes. Following this exercise, done in watercolor, we invite you to create a quick painting with colorful effects.

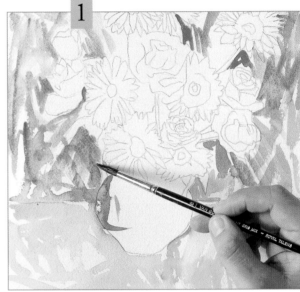

We begin by painting over a previously drawn pencil sketch, since it is easier to work this way. The tablecloth is covered with yellow brushstrokes. Then we almost immediately paint the background with transparent blue and purple washes.

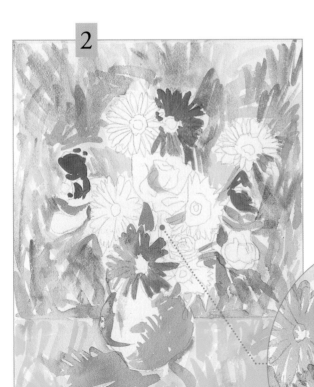

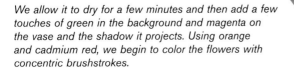

We allow it to dry for a few minutes and then add a few touches of green in the background and magenta on the vase and the shadow it projects. Using orange and cadmium red, we begin to color the flowers with concentric brushstrokes.

We continue painting the flowers with warm colors. No washes are applied to the centers of the flowers; they will be detailed later.

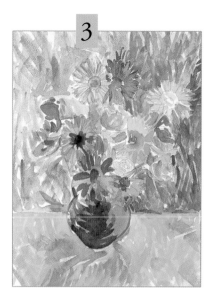

3

We cover the background with newer applications of blue and violet, and the tablecloth with yellow and ochre washes. The washes of color applied in several layers create irregular edges and cause some colors to mix with others.

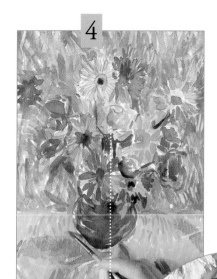

4

New yellow and orange brushstrokes stand out over the entire surface of the painting, even in the blue background. The short, overlaid brushstrokes of color in the background and in the flowers vibrate.

The final touches are applied with white gouache. We paint the daisy and the rose so they will better stand out from the picture, which is full of colors and overlaid brushstrokes.

5

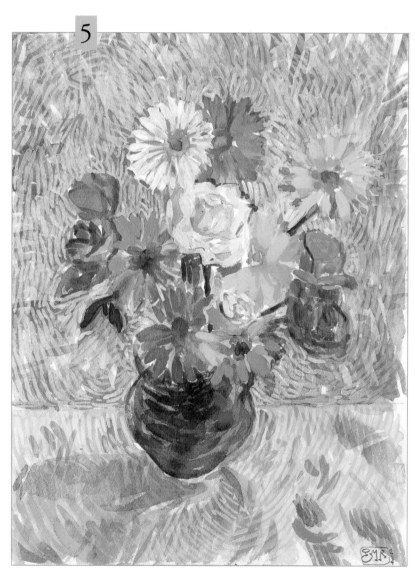

The painting is more and more saturated and dense with flowers and a contrasting background. When the watercolors are dry, we unify the background by overlaying semitransparent brushstrokes of white gouache. The darkest tones give the vase more body and indicate the stems and leaves.

Tip

The background was covered with thin strokes of white gouache that become more transparent when they dry. They help hold together the large number of brushstrokes in the background and help the bright colors of the flowers stand out.

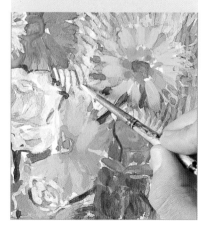

AUGUSTE MACKE *and*
the Colors of the Tunis School

Self Portrait
by Auguste Macke

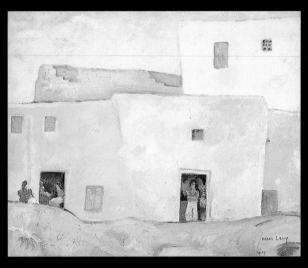

Moses Levy, Hafsia, 1927. Oil on canvas, 18½ × 22 inches (46 × 55 cm) Tunis Ministry of Culture.

The trip taken by Auguste Macke, Paul Klee, and Louis Moillet to Tunis in 1914 turned out to be an important confrontation between Western painting and Eastern painting that years later resulted in the birth of the Tunis School, a group of Arab artists who followed the Colorist style of the European artists.

Macke's interest in Mediterranean color and Islamic art was aroused by the exhibition celebrated at the beginning of the twentieth century in Munich. The artist saw in the East a world of color replete with fantasy and sensuality. According to the artist, "The image of the Orient allowed a view of a picturesque and colorful world, a passionate and at the same time cruel world, that does not participate at all in the growing disenchantment and the graying of Western civilization." It was a matter of fully embracing color, and a premeditated rejection of the use of value and chiaroscuro in the Western tradition.

During their trip to Tunis, Klee and Macke abandoned perspective to construct paintings with surfaces covered with complementary colors, thus creating a new pictorial style based on forms that had nothing to do with reality: "Incomprehensible ideas are manifested in comprehensible forms. Comprehensible thanks to our senses, like stars, thunder, flower, like form." Macke focused the interest of his paintings on chromatic structures and the dynamic rhythm of the picture plane. "If you mix red and yellow to make orange, you give the passive and feminine yellow a frenzied and sensual strength, to which blue, the man, is essential. And certainly, blue immediately places itself alongside orange, and both colors love each other."

During the 1940s, recovering the spirit of Klee and Macke, a group of amateur and professional Arab painters founded the Tunis School, although many of them had been developing this artistic concept for twenty years. Among them were Zubeir Turki, Hedi Turki, Jallel Ben Abdallah, Moses Levy, and Abdelaziz Gorgi.

They praised the light and the beauty of the architecture, the expressiveness of color, and the unique Arabic esthetic. Like Macke and Klee, Moses Levy was taken with Tunisian color, and through a revitalization of light and color he was able to strongly and fearlessly express its beauty. The paintings of Zubeir Turki also vibrate with applications of dense and contrasting color. This artist discovered decoration in the United States, but he remained faithful to the neo-Expressionist figurative painting of the second generation of painters of the Tunis School.

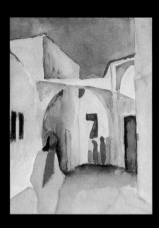

Auguste Macke, View of a Street, 1914. Watercolor, 11½ × 8¾ inches (29 × 22 cm), Städtliches Museum of Mülheim.

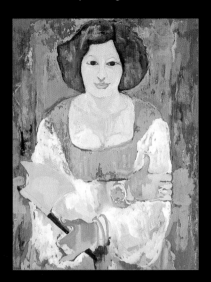

Zubeir Turki, Girl with a Fan. Gouache and oil, 24 × 16 inches (60 × 40 cm), collection of the artist.